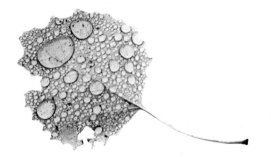

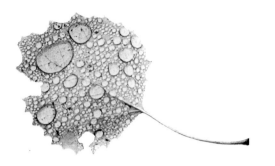

In Spite of Everything, Yes

Springs Industries Series on the Art of Photography

Published on the occasion of the exhibition

In Spite of Everything, Yes

August 30 through October 26, 1986

Hood Museum of Art

Dartmouth College, Hanover, New Hampshire

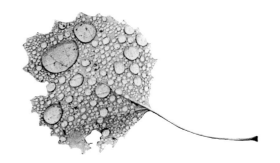

In Spite of Everything,

Yes

Edited by Ralph and Caroline Steiner

With a foreword by Peter Smith

Published for the Hood Museum of Art, Dartmouth College

by the University of New Mexico Press, Albuquerque

This exhibition and catalogue have been made possible
through the Philip Fowler Fund, the Hansen Family Fund,
the William B. Jaffe and Evelyn A. Jaffe Hall Fund,
the Marie-Louise and Samuel R. Rosenthal Fund,
and the Vermont Council for the Arts.

A special grant from Springs Industries, Inc. has supported the
catalogue and made it possible for the exhibition to travel.

Acknowledgments

Page 18: John Cheever, from "The Ocean," and "A Vision of the World," *The
Stories of John Cheever.* Copyright © 1978 by Alfred A. Knopf, Inc. Reprinted
by permission of Alfred A. Knopf, Inc.

Page 20: e. e. cummings, from *Complete Poems 1913–1962.* Copyright © 1947 by
e. e. cummings; renewed 1975 by Nancy T. Andrews. Reprinted by
permission of Harcourt Brace Jovanovich, Inc.

Page 25: Dag Hammarskjold, from *Markings,* translated by Leif Sjoberg and
W. H. Auden. Translation copyright © 1964 by Alfred A. Knopf, Inc., and
Faber & Faber Ltd. Reprinted by permission of Alfred A. Knopf, Inc.

Page 42: Sophocles, from *The Trachiniae,* lines 125–130.

Page 52: *C. P. Cavafy: Collected Poems,* edited by George Savidis. Translation
copyright © 1975 by Edmund Keeley and Philip Sherrard. "Che Fece . . . Il
Gran Rifiuto." Reprinted by permission of Princeton University Press.

Page 62: Sean O'Casey, last paragraph of *Autobiography.* Reprinted by permission
of Carroll & Graf Publishers, Inc.

Page 66: e. e. cummings, from "one xxxix," *is 5.* Copyright © 1926 by Horace
Liveright. Reprinted by permission of Liveright Publishing Corporation, Inc.

Page 100: Jonathan Edwards, from *Personal Narrative.*

Page 121: Vincent Van Gogh, from *The Complete Letters of Vincent Van Gogh.*
Reprinted by permission of New York Graphic Society Books / Little, Brown
and Company.

Page 133: Gerard Manley Hopkins, "Pied Beauty."

Library of Congress Cataloging-in-Publication Data

In spite of everything, yes.
 Catalogue of an exhibition held at the Hood
Museum of Art, Dartmouth College, Hanover, N.H.,
Aug. 30–Oct. 26, 1986.
 1. Photography, Artistic—Exhibitions. I. Steiner,
Ralph, 1899–1986. II. Steiner, Caroline. III. Smith,
Peter, 1933– . IV. Hood Museum of Art.
TR646.U6H365 1986 779'.074'01423 86–19162
ISBN 0–8263–0941–0
ISBN 0–8263–0942–9 (pbk.)

Contents

Lenders to the Exhibition

The Art Museum, Princeton University, Princeton, N.J.

James H. Barker

Eleanor Briggs

Robin Brown

Paul Caponigro

Center for Creative Photography, University of Arizona, Tucson, Az.

William Clift

Gabriel Amadeus Cooney

Robert Dawson

Elliott Erwitt

Richard Farrell

Douglas Frantz

George Gardner

William Garnett

Ernst Haas

Ken Heyman

Evelyn Hofer

International Museum of Photography at George Eastman House, Rochester, N.Y.

Dewitt Jones

Tamara Kaida

Michael Kenna, care of Stephen Wirtz Gallery, San Francisco, Ca.

Estate of André Kertész

B. A. King

Susan Landgraf

Arthur Lazar

Stephen W. Lewis

Jerome Liebling

Marlborough Gallery, Inc., New York, N.Y.

Joel Meyerowitz

Museum of Modern Art, New York, N.Y.

The Oakland Museum, Oakland, Ca.

Olivia Parker

Philadelphia Museum of Art, Philadelphia, Pa.

Eliot Porter, care of Scheinbaum and Russek, Santa Fe, N.M.

Julie F. Pratt

Barbara Rogasky

Milton Rogovin

Walter Rosenblum

John Sheldon

Lou Stoumen

David Vestal

Alma Lavenson Wahrhaftig

Sandra Weiner

Murray Weiss

Ulrike Welsch

Marion Post Wolcott

Helen Wright

Anonymous Lender

Preface

Dartmouth College has many illustrious alumni, but there is no one of whom the College is prouder than the photographer and cinematographer Ralph Steiner. A member of the Dartmouth class of 1921, Steiner was given an honorary doctorate of fine arts by the College at its commencement exercises this past June. His work has been the subject of several exhibitions at Dartmouth, the most recent being a retrospective exhibition organized by Jan van der Marck in 1979. When the time seemed right for another Steiner exhibition, I asked Ralph whether he would be willing to serve this time as curator rather than as subject. It seemed to me that his strong opinions on the potential of photography as a medium of communication deserved a different kind of expression, one that could be conveyed most directly through a selection of photographs that he admired. He enthusiastically agreed, provided we acknowledge the crucial participation of his wife, Caroline Steiner, in the project. Caroline deserves far more than an acknowledgment of thanks. She and Ralph gave their hearts and minds to the task of making this exhibition and its catalogue a reality. Rarely have I seen a more powerful force at work than their mutual love and determination. On July 13, 1986, Ralph Steiner died after a long illness. Sadly, our exhibition has become a memorial tribute. Thanks to Caroline Steiner's continuing help, it provides the most fitting possible expression of Ralph Steiner's joyful perspective on the world.

A number of people deserve special thanks for their contributions. Malcolm Cochran, our curator for exhibitions, and Rebecca A. Buck, our museum registrar, combined their formidable administrative skills to bring this project to completion within a very tight deadline. Ms. Buck was ably assisted by Richard C. Morell, Jr., Dartmouth class of 1986, and Susan Moody, class of 1987, who handled much of the correspondence and record-keeping. We were fortunate as well to have the benefit of the wisdom of two outside consultants: George Dimock, now assistant director at the Krannert Art Museum, who assisted Ralph Steiner in assembling an initial group of photographs for consideration; and Joanne Hardy, who guided the exhibition through the final selection process and compiled the exhibition checklist. I could go on to name every member of the museum staff, as well as others at the College, for this has truly become a Dartmouth "family" project. In the interest of brevity, however, I shall simply cite the kind assistance of Hilliard Goldfarb; George H. Colton '35; Ralph Steiner's classmate, Orton H. Hicks, Sr., '21; and Peter Smith. We are also extremely grateful to Dana Asbury at the University of New Mexico Press. Special thanks go to Springs Industries for funding the catalogue and the traveling portion of the exhibition. Their tradition of support in the field of photography has been continued by this generous contribution. We also extend our gratitude to David Finn and Philippa Polskin for their kind assistance in making the tour possible.

Final thanks, as always, must go to the lenders, who in most cases were the very photographers whose work is included in this exhibition. The agreement to lend was frequently accompanied by the message, "I'd do anything for Ralph." In the course of this project, we constantly encountered such reminders of the high esteem in which Ralph Steiner was held by those who see the world more acutely than the rest of us: his fellow artists.

Ralph Steiner had a profound commitment to the relational and associational possibilities of photography. It may even be disarming for us to confront its intensity. In fact, he was never comfortable with the avant-garde role Alfred Stieglitz established for photography in America, although much of his own work has been appreciated in purely formalist terms. Historically, this is a particularly advantageous moment for reviewing Steiner's "point of view." (*A Point of View* is the title of a book by Steiner published by Wesleyan University Press in 1978.) We are now coming to see modernist aestheticism as an ideology, with losses and gains like any other cultural ideology. In the pluralist climate of the 1980s, Steiner's delightfully freewheeling expressiveness is more likely to be appreciated and understood on its own terms. The pleasure, as this exhibition proves, is altogether ours.

From an art historical perspective, Steiner's work is noted for its bold address of unconventional subjects that helped open photography to the commercial and graphic realities of the urban environment. This exhibition emphasizes another, equally important aspect of Steiner's contribution: his insistence on the power of the photograph to produce communicable meaning, to have an educative impact that is both social and sociable.

In this sense, Steiner's didactic intent recalls the ethical understandings associated with nineteenth-century Ruskinian aesthetics. But his own aesthetic is more deeply rooted in an older, still continuing New England tradition of iconoclasm in the service of moral clarity. Above all, Steiner's point of view recalls Ralph Waldo Emerson's prescriptions for an authentically American "poetry," regardless of medium. Emerson taught us to turn apparent eccentricity inside out. Self-trust is the precondition of original perception, inspired by a democratic intent of "communicating, through hope, new activity to the torpid spirit." That is from Emerson's *Nature* (1836), which provides a more rewarding commentary upon Steiner's cloud studies than the picturesque notions assumed in the landscape traditions of, say, Turner and Constable.

Understanding Steiner's aesthetic in this context provides the best measure of his distance from European modernism and the Steiglitz school, where form is pitted against every competing human interest. "Natural facts are also spiritual facts," Emerson stated, insisting on the moral force of the imaginative freedom thus inspired. "Nature," he declared, "is so pervaded with human life that there is something of humanity in all and in every particular." This is a great and simple truth, and each of the photographs Steiner has selected reminds us of it in some special way that is, for me at least, quite memorable.

There is another aspect to the philosophy of Ralph Steiner that has links not only with Emerson's *Nature*, but also with Rousseau, Blake, and Baudelaire's insistence upon *la jeunesse retrouvée*—the recovery of childhood as the essence of genius. Steiner shows its timeless relevance, as a contagious enthusiasm that can emerge in art of all kinds, of many times and places, in "folk" art and in "high" art equally. The magic of childhood informs his own irrepressibly playful letters, notes, and sketches, as well as his photographs. Its chief message is richly declared in this exhibition and catalogue: delight in the world's miracle, which is never truly itself until it is shared with others.

Jacquelynn Baas
Director, Hood Museum of Art

In Spite of Everything, Yes

Why, today, a collection of affirmative photographs?

To be a Pollyanna in our time is to be a fool. At this moment we are not living the very most joyous slice of the world's history. Glancing at the front page of the *New York Times* or listening to the news on any day it is overwhelmingly plain that the world is full of suffering, violence, and the dark shadow of total annihilation. It seems as if it were not sufficiently dangerous that differing peoples can wipe each other out; we have added the possibility of wiping ourselves out. How can a photographer say "yes" to such a world?

Looking at the work of today's photographers I see them responding to their surroundings in three main ways: as "no" photographers, as "ambiguous" photographers, and as "yes" photographers.

It is not surprising that there is a powerful set of no-sayers. As I write, two outstanding ones come to mind. One, Joel Peter Witkin, delivers to us a sort of witches' brew of darkness, and craziness. His cleverly arranged compositions show us 300-pound nude women surrounded by floating fetuses. (In the bright sunshine of Albuquerque, New Mexico, he told me, straightfaced, that he collected these.) The other very successful no-sayer, Richard Avedon, has just published a book of people, supposedly typical of the western U.S. All of the subjects, without exception, are infected with a kind of spiritual acne which saps their will and hope for joy. The book breathes despair, and underneath it a kind of contempt for the potential of the human being. The photographer has chosen to show only losers. Earlier in his career he pictured the famous and "successful," and through harsh lighting and techniques of developing and printing managed to make most of them look like corpses. This is his vision of the world, to which, of course, he is entitled. Both these no-sayers have numerous admirers and imitators, but few of them have managed to buy lenses made with as deep a shade of negating glass.

Another widespread reaction to our world is the school of "ambiguity," or obscurity-photographers. They consciously refuse to make any statement in their work, for or against the subject. They explain in extensive and rather difficult writing that they are not involved with feeling or content in their pictures. They take no responsibility as artists but state that each observer is to put into the photograph whatever he brings to it. Sometimes the subject is meticulously sharp, but one is hard pressed to understand why it was chosen at all; sometimes it is purposely blurred so that one has no idea what it is. This is an especially popular school in the 1980s. There even exists a batch of photographers (camera-wielders would be a better designation) who literally shoot from the hip, thus preventing themselves from in any way composing the subject's elements in the ground glass. Accident is the name of the game.

And the third group, the yes-sayers? Let me make clear at once that they are not people who keep their eyes squeezed shut to the sinister aspects of the world around them. Some of them have made great images of tragedy and pain. But this is not the aspect of their work with which we are dealing here. We are dealing with the particular ability to see the world and in spite of everything dark and discouraging to rejoice in evidences of "yes." These are artists who have kept their zest for life. As the Latin saying has it, "*Dum vivimus, vivamus*" — while we're alive, let us live. This takes a certain faith in at least the possibility of good. I like

the wonderful addition to the story of Moses, when he was leading the children of Israel out of bondage. The voice of the Lord spoke to him, saying he must part the Red Sea, so his people could pass over. And Moses raised his hand and sent forth this tremendous command. But at first nothing happened, nothing at all. Only when the first man stepped out into the waters did the sea start to withdraw.

These are photographers who are not ashamed to see compassion, grace, energy, and the capacity for survival in many kinds of people. Their eyes are open to beauty—a very unfashionable word—in landscapes, in interiors, in natural or manmade objects. To them a quiet, understated countryside may say yes as well as an awesome, dramatic one. They may lift our spirits with an eye-stretching, distant view, or by the intimacy of an object seen in loving close-up. And, thank God, they have not lost their sense of humor.

It is, then, just because we live in a troubling world that I wanted to collect these images of affirmation. A few of these pictures are famous, but in general I have tried to find fresh and unfamiliar work by the younger generation of photographers. They generously share their vision with us, and I would like to invite you to join them in the ancient Hebrew toast, "L'Chaim!"—To Life!

Ralph Steiner
Thetford Hill, Vermont

Foreword

"O be joyful in the Lord, all ye lands! Serve the Lord with gladness, and come before his presence with a song." That's the psalmist in Ralph Steiner, offering us something to live our lives by, and it seemed to me an appropriate beginning to this celebration of what this photographer and latter-day psalmist holds dear. It seems to me, you see, that with this exhibition and the book based upon it, Ralph has gone one better than Felix Mendelssohn, who wrote Songs that were Without, merely, Words. "In Spite of Everything, Yes" gives us a hundred songs that are Without both Words and Music.

The same principle is at work in both instances. Mendelssohn sent a letter to someone who inquired about the meaning of his pieces, telling him that it was because music could express his feelings more precisely than words that he had written the Songs Without Words in the first place. Ralph Steiner once lent me a book which had an inscription, from the person whose pictures it contained, in which Ralph was described as someone who "thinks with his eyes." It's all part of the same truth: that these complicatedly simple creatures who call themselves human beings give and receive messages in many more ways than one.

We talk about body language, and we used to talk about the language of love; without having to dig for more examples of phrases that make it more explicit we know that voices of one kind or another are all around us, all the time. And it seems reasonable to me to believe that in every language-without-words there is a way to say "Yes"; and that, further, as with most languages-with-words, it can be said in, as it were, one syllable.

One syllable: that's a problem that has to be dealt with. We find it difficult, we who are thoughtful, sensitive, responsible people, to have patience with, let alone to believe, politicians and sophists of all kinds, when they state their case in terms of black and white, when they talk as though complex questions had easy answers—because *we* know how very complex most things are. And yet, here we are, Steiner and I and all the photographers whose work is reproduced here, insisting that a one-syllable word should be the last word. I am not trained in these matters, so the metaphor I choose to justify my point of view may not be as convincing as I would like it to be, but it seems to me that "In Spite of Everything, Yes" tells you no more than that your destination is certain and your compass true. It does not, as the bogus simplifiers do, try to kid you that the route is known, the road is paved, and the going is easy. As Ralph suggests in his introduction to this selection of images, the kind of Pollyanna who thinks that travelling is easy in these times is nothing but a fool.

There's more to this business, though, than simply affirming the virtue of engraving the word "Yes" on your compass. I want to make a case for affirmation as the appropriate response to the era in which we live. I want to open minds to the possibility that there may be solid ground under the feet of those who join Ralph Steiner in giving you these images of the world around us. To do such a thing is to seem to ignore the fact that the human race turned a corner in 1945 and found itself face to face with horror and cruelty on a previously unimagined scale. How can we, in 1986, reconcile "In Spite of Everything, Yes" with the kind of point George Steiner, for example, makes in *In Bluebeard's Castle*: "It may well be that it is a mere fatuity, an inde-

cency to debate of the definition of culture in the age of the gas-oven, of the arctic camps, of napalm. . . . The numb prodigality of our acquaintance with horror is a radical human defeat"? How can we take any blessing from Wordsworth and his conviction about the vanquished Toussaint L'Ouverture:

> . . . thou hast great allies;
> Thy friends are exultations, agonies,
> And love, and man's unconquerable mind,

knowing as we do that "psychiatric warfare" has shown that a man's mind, at least in any specific case, can all too easily be conquered and laid waste? I believe that the answers are still affirmative.

It is not clutching at straws to suggest that there is something in the fact that even someone who has brought his intellect to bear on the phenomenon of evil in our generation, as George Steiner has, says "may well be" rather than "is"; describes the prodigality of our acquaintance with horror as a radical defeat for our humanity, not the annihilation of it. And my own "at least in any specific case" speaks to the fact that so long as even one mind remains unconquered by either the psychiatric ward or any of the other phenomena that have the power to drain the human spirit—hunger, illiteracy, exploitation, rape, and all of the rest—the possibility surely remains that it is such horrors that will themselves be conquered. When all is said and done, it must be seen (and God knows there is nothing glib in the words that follow) that Auschwitz was not the last word. Neither will the Gulag Archipelago be the last word, nor will Apartheid. And, inexplicable though it may be, in rational terms, "In Spite of Everything, Yes" makes me believe that even though there is the possibility of a genuine "last word," in the shape of an actual finger that is actually pressing down on the button, the same forces which have prevented every other final catastrophe will stop that one too.

It is this belief that, for me, makes the idea of "Better Dead Than Red" so dangerous and defeatist a doctrine on which to base foreign policy. (This is not to say that there is not a cause for which I would be willing to give my life; I believe too strongly in Ruskin's "If a man does not know when to die, he does not know how to live.") The fact that is surely inescapable, though, is that once you are dead you cannot change your mind (or anyone else's, for that matter), whereas if you are merely Red, the possibility exists that you will do just that, as many another Red has done and lived to tell the tale. It seems to me that Ralph Steiner, in asking us to look at "In Spite of Everything, Yes" is standing alongside the South African poet, Roy Campbell:

> Against a regiment, I oppose a brain
> And a dark horse against an armoured train.

"Ah," you say, "so 'In Spite of Everything, Yes' is just another way of saying 'Where There's Life There's Hope!'" Not a bit of it. It has very little to do with anything as passive as hope. And nothing whatever with "Pie in the Sky" or Pollyanna or Mr. Micawber or ostriches with their heads in the sand. The kind of affirmation present in the pictures Ralph has chosen as a kind of last will and testament is something infinitely more powerful than hope and altogether more honest than moral evasion. It speaks of conviction and courage and certainty and "*Never* Say Die."

What this series of photographs does, it seems to me, is to provide a double ration of sustenance for those people for whom "In Spite of Everything, Yes" is the equivalent of Luther's "Here I stand. I can do no other." In the first place it lets us know that landscapes and bowls of fruit, and leaves on a pond, and a trillion other beautiful sights, can "Say 'Yes'," as well as people of every size and description. And in the second it makes it very clear that having a photograph of those "Yea-sayers" can do something similar for us as being in their actual presence. But, because words are more my medium than graphic images, let me suggest to you that you will also find "Yes" in innumerable poems and essays and novels and plays—they can be fountains of truth too. So can examples from any of the other arts; and just to offer something that can supplement the affirmations made by the photographers Ralph has brought to your attention here, let me turn to a composer whom he loves.

Let me lead you to a piece of music, to some few hundred notes that contain a truth which is of inestimable value in my life (and the lives, I have no doubt, of millions who have heard it as I have, and of millions more who will hear it thus in centuries yet to come), a truth for which, in my opinion, a quite inadequate equivalent may be found in the English words "In Spite of Everything, Yes" (confirming, in a sense, Frost's definition of poetry as that which gets lost in translation).

Some years ago, when I was away from my family for a number of months, it occurred to me that I ought to let them know what I would like done if I should meet with a fatal accident or disease. (It has struck me since that there is probably a good correlation between the size of a person's ego and the amount of detail that that person goes into when setting down what should be done after the mortal coil has been shuffled off. But that's a subject to be taken up in a different essay, I'm sure.) One of the things I specified was the music I would like to have played at any kind of memorial gathering that might be arranged. In a recent *New Yorker* column, Andrew Porter writes about the work I asked for:

"The works of Schubert's last year—Book II of 'Winterreise,' 'Schwanengesang,' the late piano sonatas, the C-Major Quintet, the E-Flat Piano Trio—are among those the world holds most dear: fashioned by that marvellous mind which, as if aware of death's approach, hastened to lead listeners into new realms of beauty and sorrow, of peace after strife and order after anguish."

Can we begin to imagine what it must have meant if the 31-year-old Schubert was, in fact, aware of death's approach? This man who was in no doubt about how marvellous a mind he had been given; this man about whom his friends would still say forty years after his death, "When we were with him, we were the happiest people in the world." Can "In Spite of Everything, Yes" have been a part of his response to what he faced? Go to the E-Flat Piano Trio and you will find out.

It's a long work, and since people don't like memorial gatherings to outstay their welcome I asked for just the second and fourth movements. The second has one of those heavenly melodies for which the epithet "Schubertian" is the only one that makes sense. That melody returns in the fourth movement: the first time it comes fleetingly, a kind of ghostly aberration in the midst of the high spirits of the kind that *allegro moderato* finales commonly display—the people who heard the work's first performance might well have found it hard to believe their ears. But that brief and unelaborated double statement of the melody is, it turns out, only a foretaste of a miracle that Schubert has in store for us. Many minutes later, only fifty bars from the end of the work, the indescribable melody returns again, and this time "unser guter Franz," as his father called

him in a letter written to tell his brother of the composer's death, makes it grow and grow until it fills the heart to overflowing. In musical terms, what happens in those forty bars or so is this: the theme is condensed, its four phrases reduced to two and those two given unequal prominence; at the same time the meter is changed—the combined effect of which is to make the music go both faster and slower; and while all that is happening, Schubert employs one of his most magical effects and shifts from the minor mode into the major. What happens there in the universal language which lives in the soul of music (as it lives in all beautiful and life-affirming people, and art, and natural phenomena), is that the music becomes a message. It is a message, like the ones that are to be found in the photographs here, which helps us to face whatever life, or death, has in store for us. It is a message for which mere words, even "In Spite of Everything, Yes," can give but a threadbare and impoverished approximation.

<div align="right">

Peter Smith
Strafford, Vermont

</div>

In Spite of Everything, Yes

. . . I awoke at three, feeling terribly sad, and feeling rebelliously that I didn't want to study sadness, madness, melancholy, and despair. I wanted to study triumphs, the rediscoveries of love, all that I know in the world to be decent, radiant, and clear. . . .

And I know that the sound of rain will wake some lovers, and that its sound will seem to be a part of that force that has thrust them into one another's arms. Then I sit up in bed and exclaim aloud to myself, "Valor! Love! Virtue! Compassion! Splendor! Kindness! Wisdom! Beauty!" The words seem to have the colors of the earth, and as I recite them I feel my hopefulness mount until I am contented and at peace with the night.

JOHN CHEEVER

Consider the Children

i thank You God for most this amazing

day: for the leaping greenly spirits of trees

and a blue dream of sky; and for everything

which is natural which is infinite which is yes

(i who have died am alive again today,

and this is the sun's birthday; this is the birth

day of life and of love and wings: and of the gay

great happening illimitably earth)

how should tasting touching hearing seeing

breathing any—lifted from the no

of all nothing—human merely being

doubt unimaginable You?

(now the ears of my ears awake and

now the eyes of my eyes are opened)

e.e. cummings

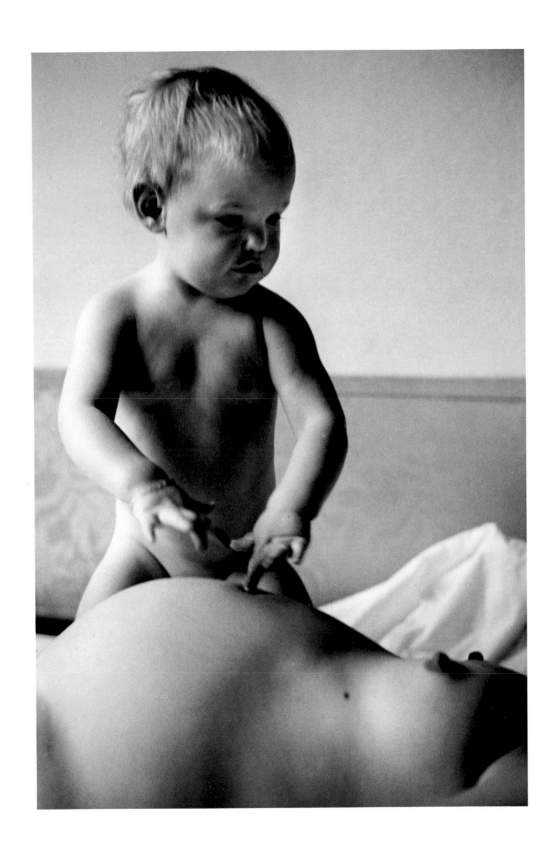

Ken Heyman *Untitled* (Mommy's tummy)

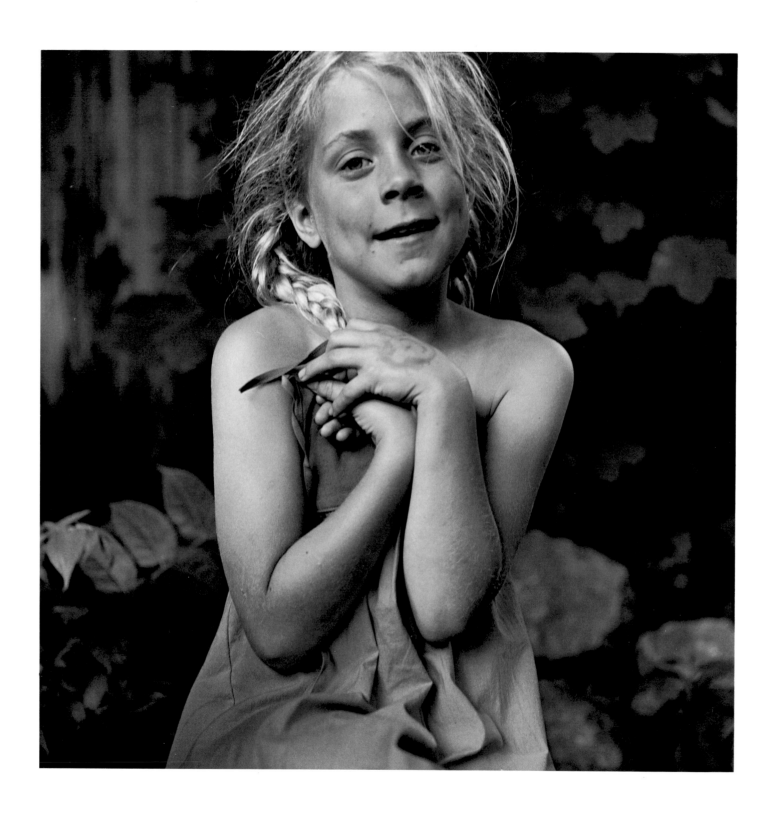

Tamara Kaida *Woodsprite*

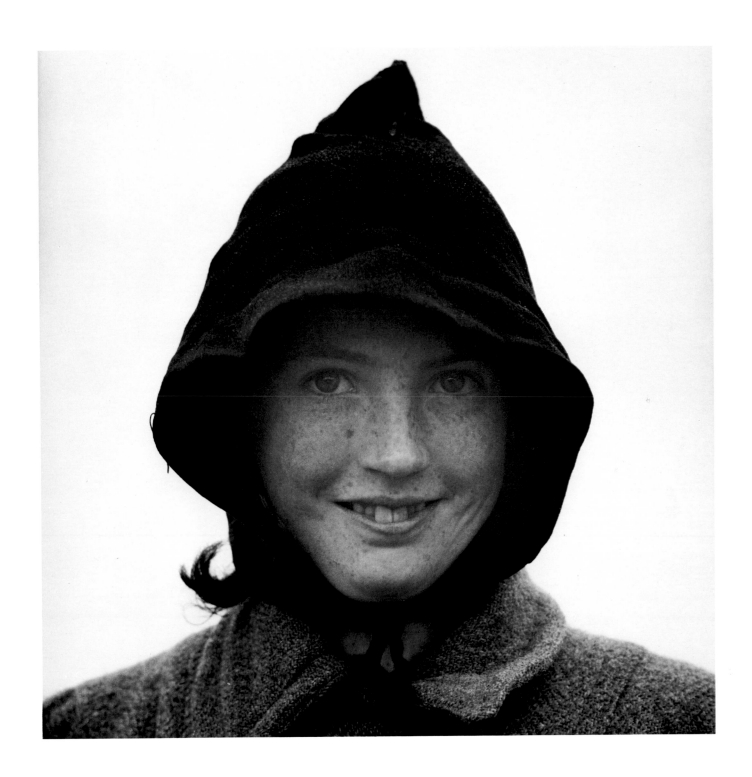

Dorothea Lange *Irish Child (County Clare, Ireland)*

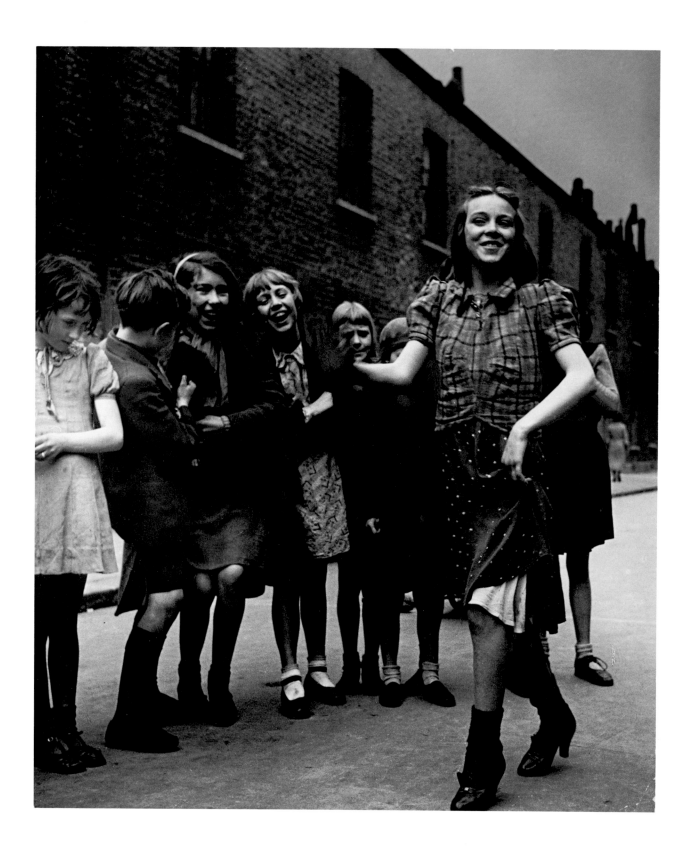

24

Bill Brandt *East End Girl Dancing the Lambeth Walk*

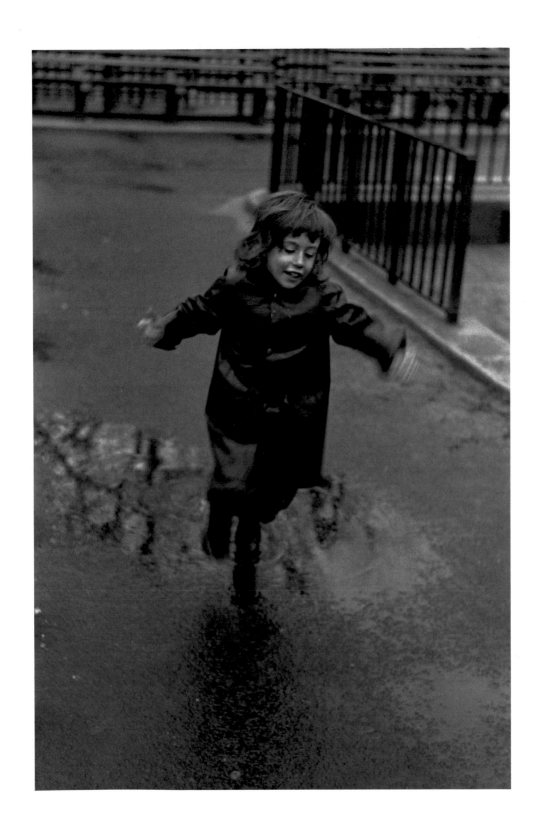

David Vestal *Anne Vestal in Washington Square, New York*

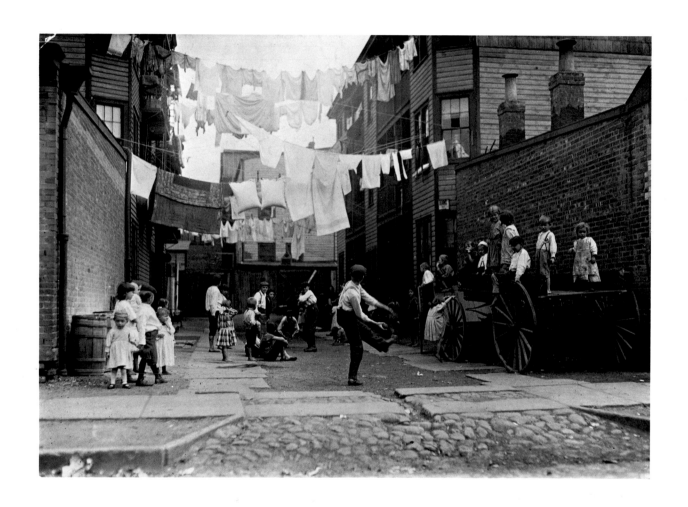

Lewis Hine *Playground in a Tenement Alley, Boston*

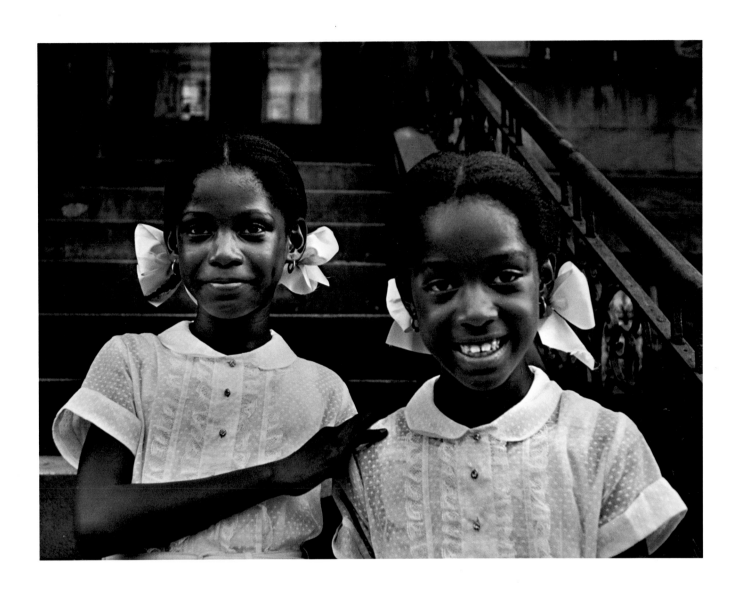

Ken Heyman *Untitled* (Girls with bows)

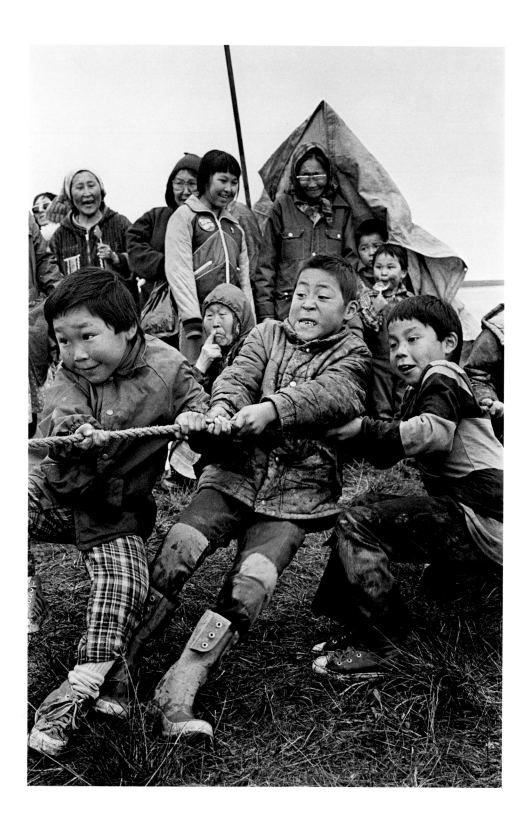

James H. Barker *Byron Hunter, Elia Charlie, Oscar River: Fourth of July at Black River, Scammon Bay, Alaska*

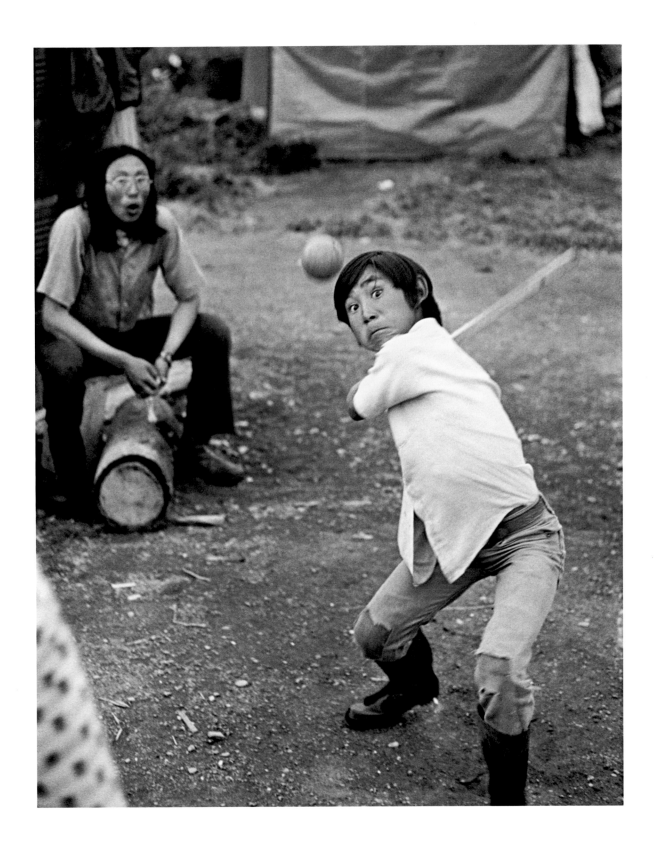

James H. Barker *Sam Anthony and Simeon Tulik: Lappball, Nelson Island, Alaska* 29

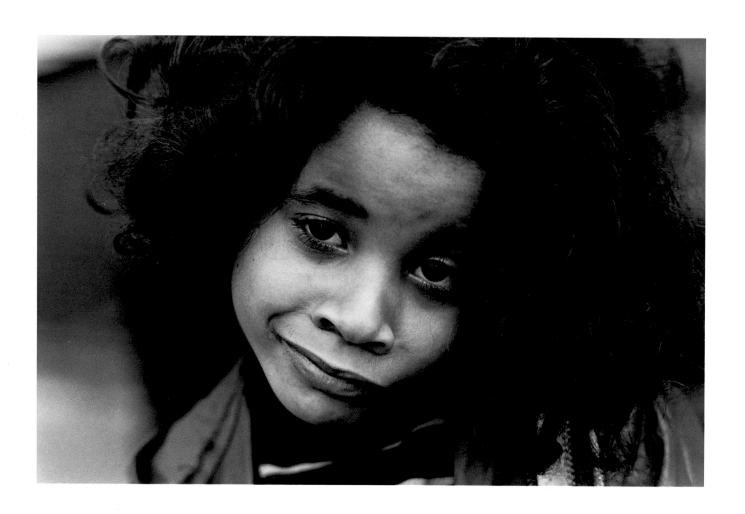

Susan Landgraf *Jessica*

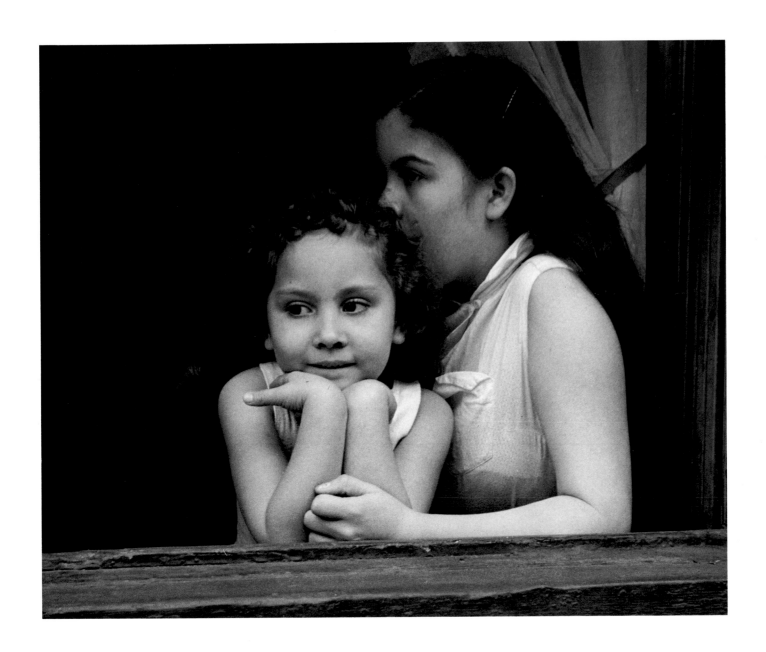

Walter Rosenblum *Two Sisters on 105th Street*

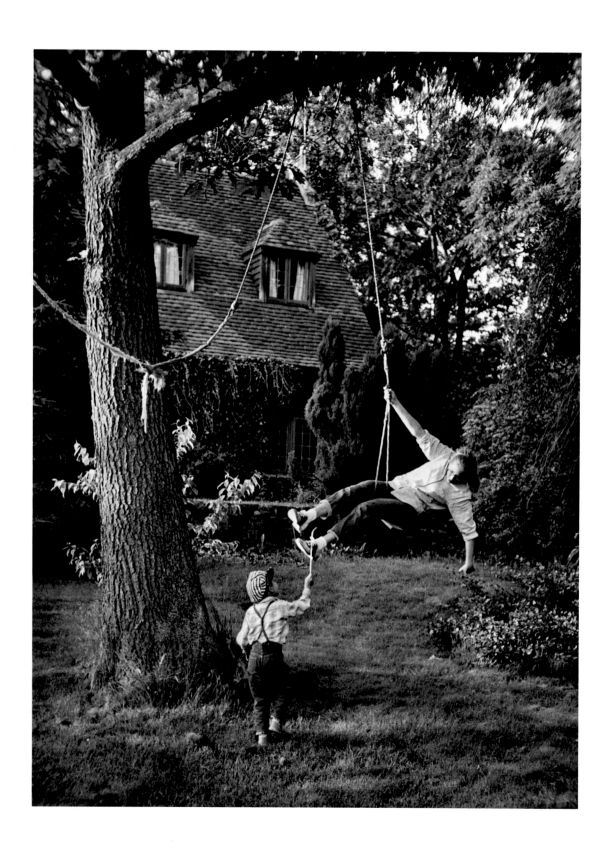

Ken Heyman *Untitled* (Girl swinging)

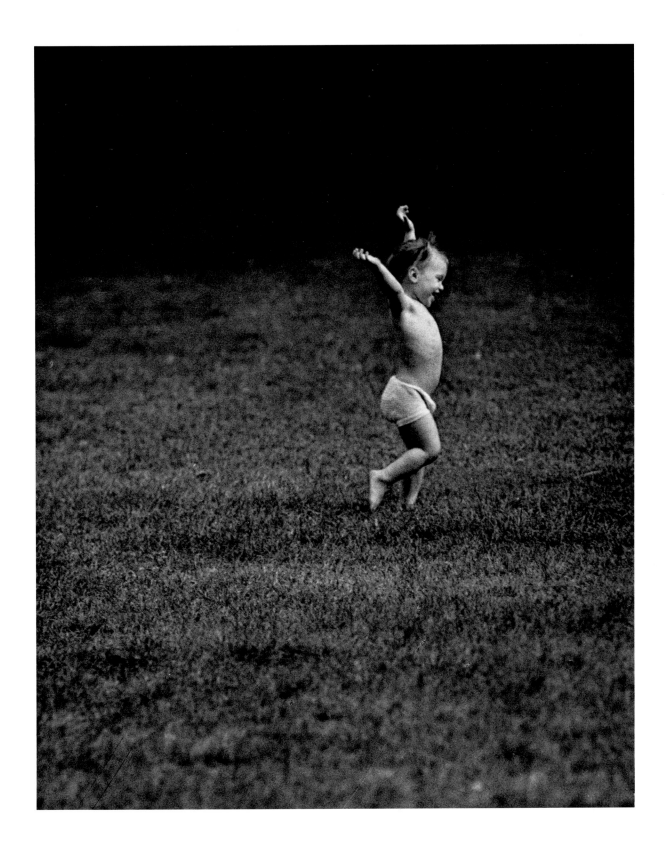

Ken Heyman *Untitled* (Child leaping)

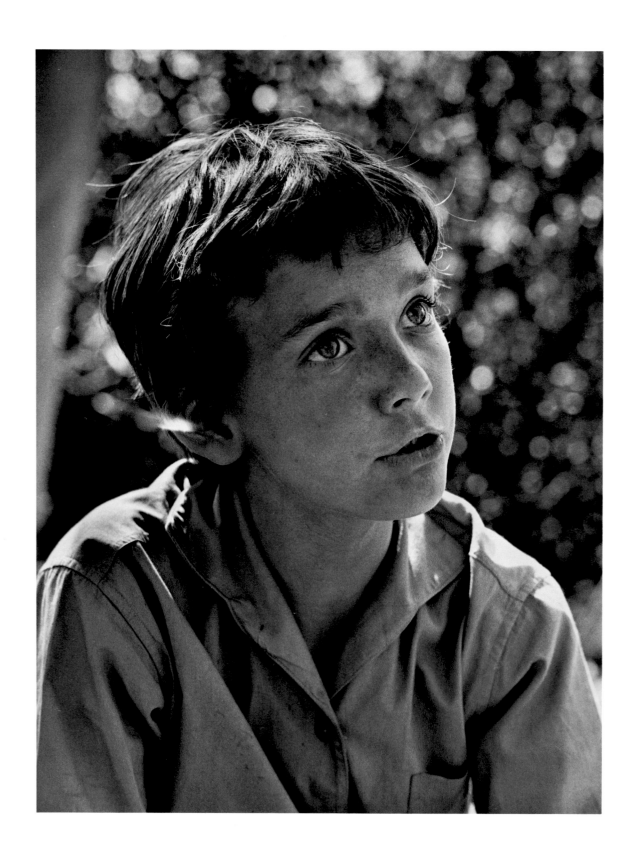

Ken Heyman *Untitled* (Girl in earnest)

God does not die on that day when we cease to believe in a personal deity,

but we die when our lives cease to be illuminated by the steady radiance, renewed daily,

of a wonder, the source of which is beyond all reasoning.

DAG HAMMARSKJOLD

And People in Their Variety

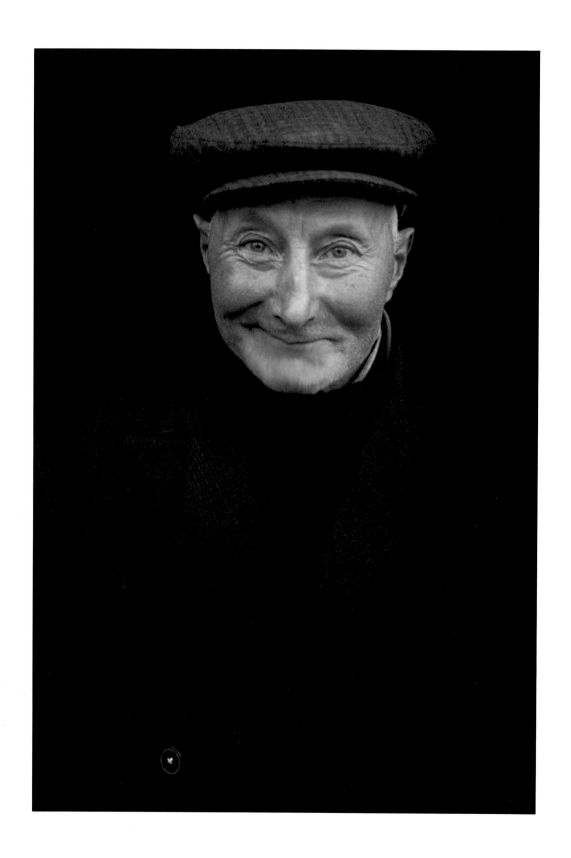

William Clift *Eduard Faitout, Vessey, France*

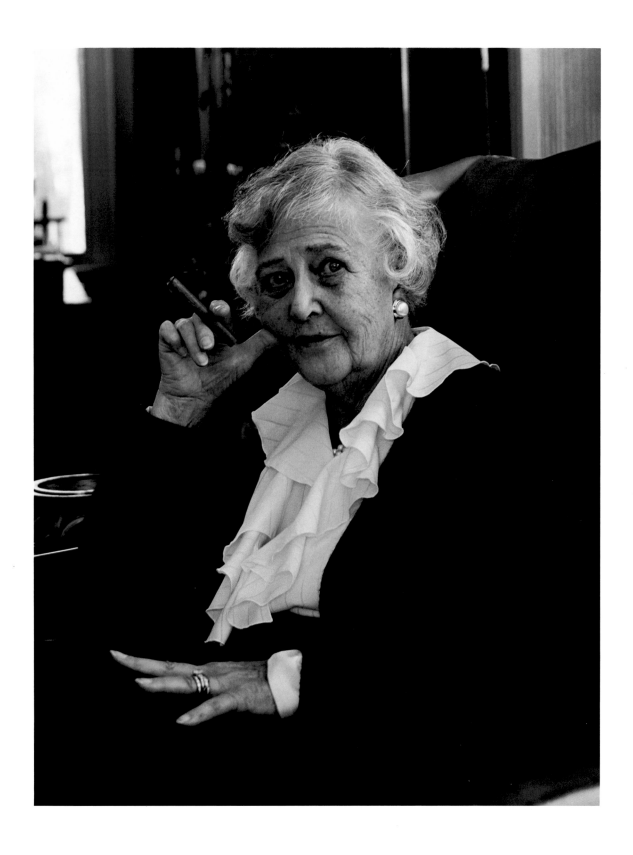

Gabriel Amadeus Cooney *Winifred Arms*

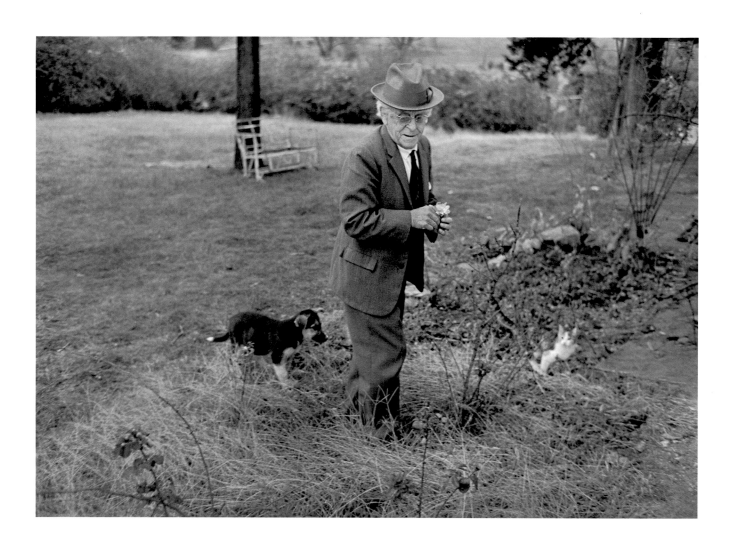

George W. Gardner *Portrait of Neihardt*

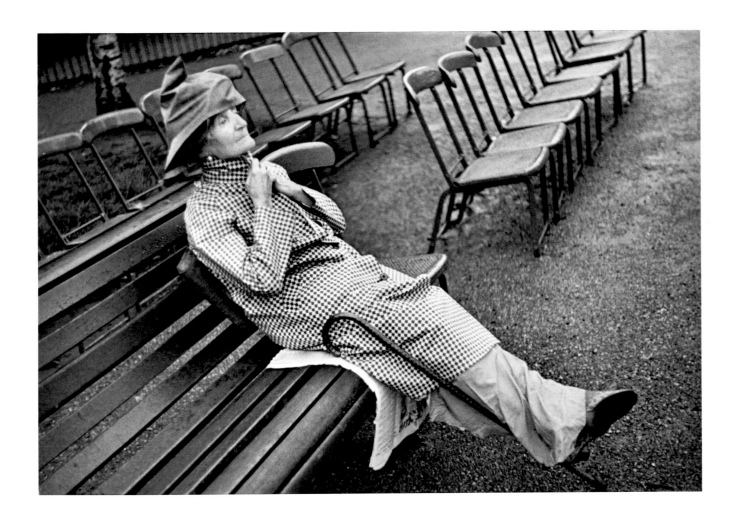

Henri Cartier-Bresson *Hyde Park, London*

You should not let all expectation of good be worn away. Nothing painless the

all-accomplishing King dispenses for mortal man; but grief and joy come circling to

all, like the turning paths of the Bear among the stars. The shimmering night does not

stay for men, nor does calamity, nor wealth. But swiftly they are gone, and for another

man it comes—to know joy and its loss.

SOPHOCLES

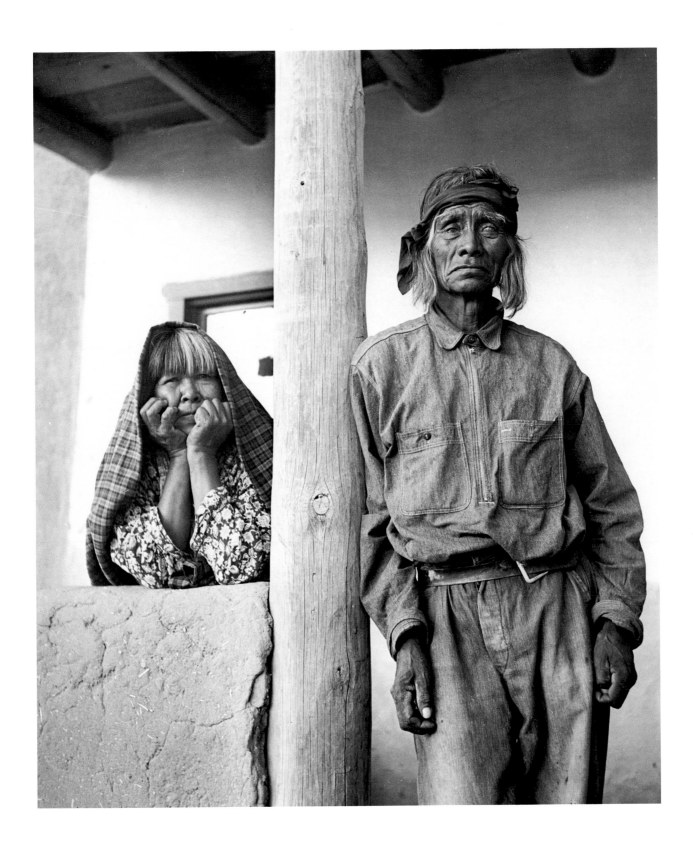

Alma Lavenson *San Ildefonso Indians, New Mexico*

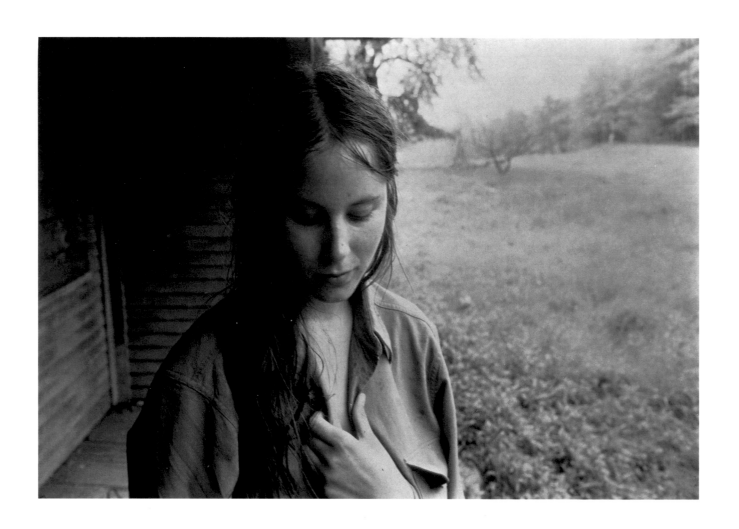

Jonathan Sa'adah *Cris at Petrell House*

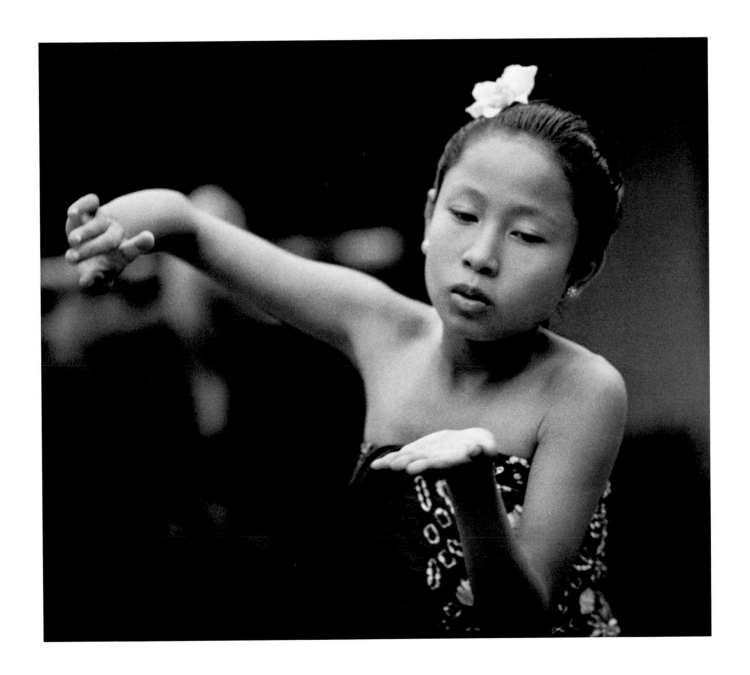

Ken Heyman *Untitled* (Indonesian dancer)

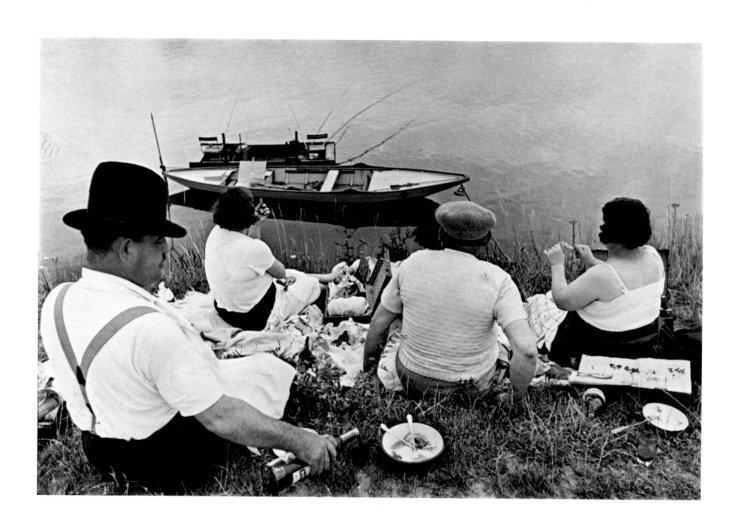

Henri Cartier-Bresson *On the Banks of the Marne*

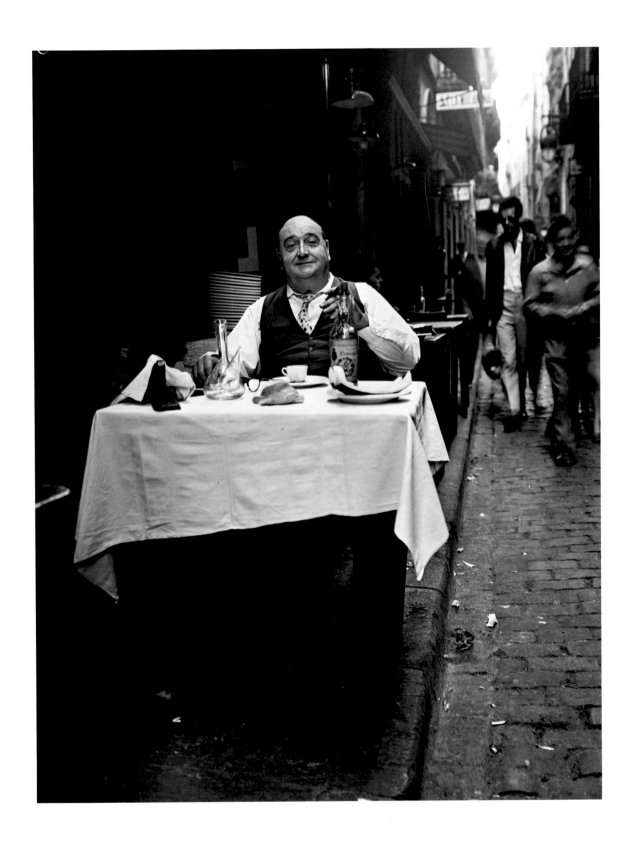

Evelyn Hofer *Proprietor of the Caracoles Restaurant, Barcelona*

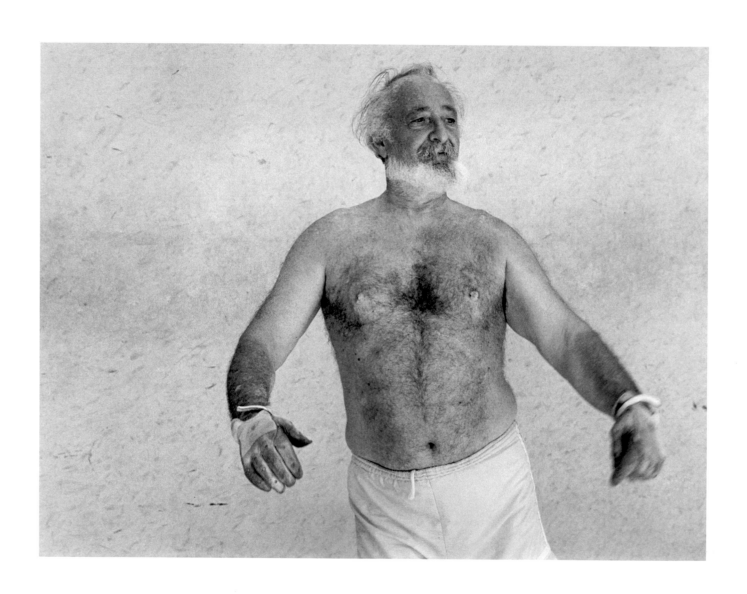

Jerome Liebling *Handball Player, Miami Beach, Florida*

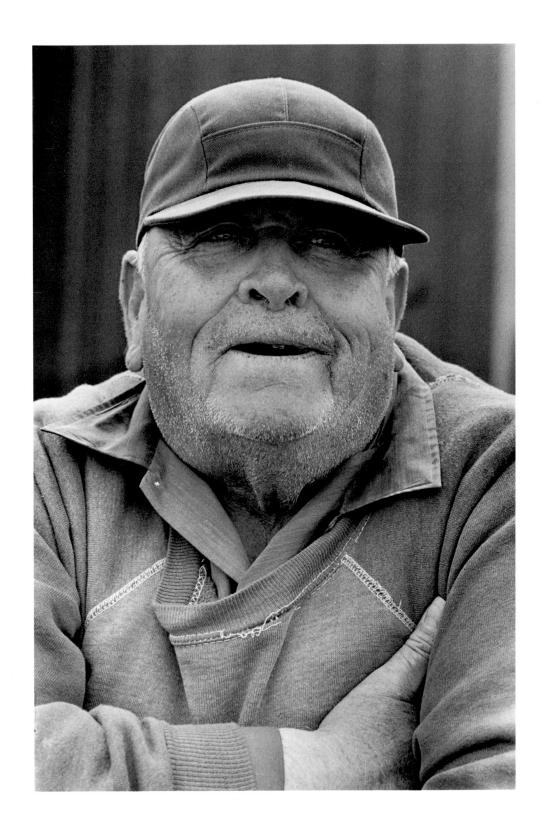

Ulrike Welsch *George Lowell*

The spirit of democracy is that spirit which is not too sure it is always right.

LEARNED HAND

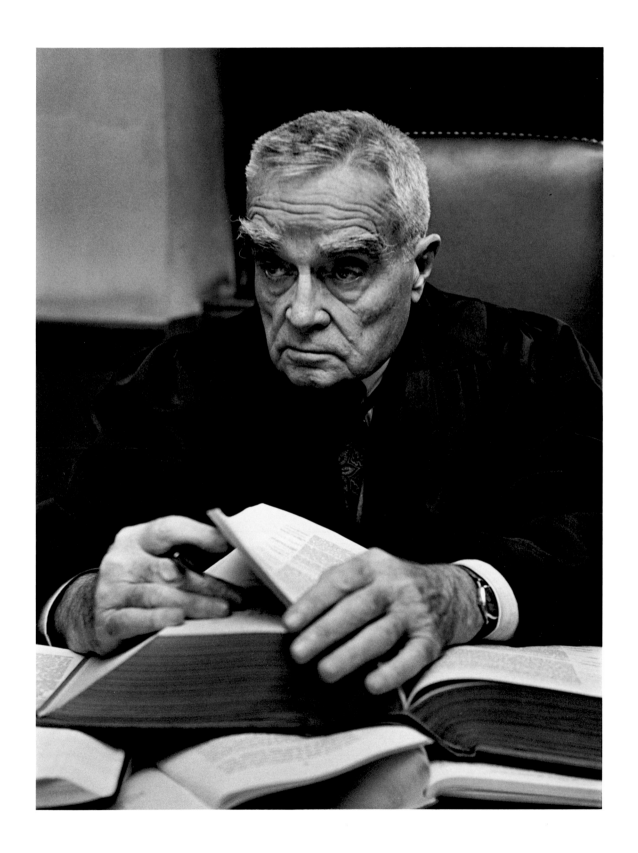

Daniel Weiner *Justice Learned Hand*

For some people the day comes

when they have to declare the great Yes

or the great No. It's clear at once who has the Yes

ready within him; and saying it,

he goes from honor to honor, strong in his conviction. . . .

C. P. CAVAFY

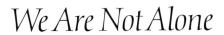

We Are Not Alone

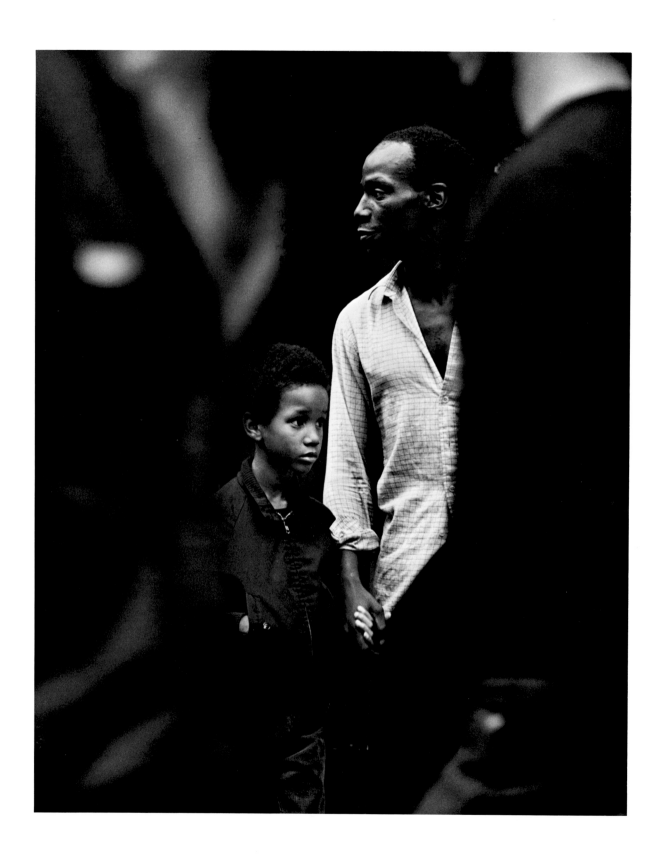

Lou Stoumen *Father and Son, N.Y.C.*

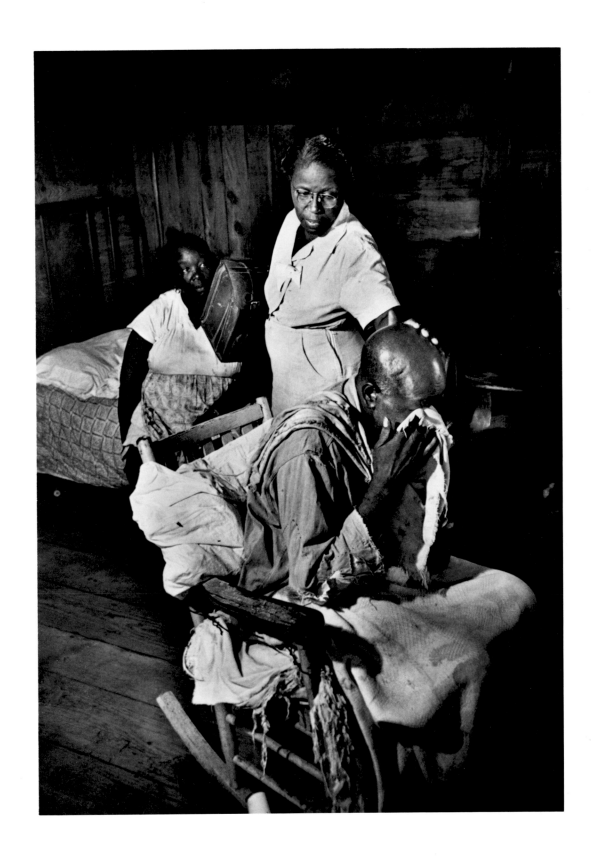

W. Eugene Smith *Maude Callen*

B. A. King *The History Prize*

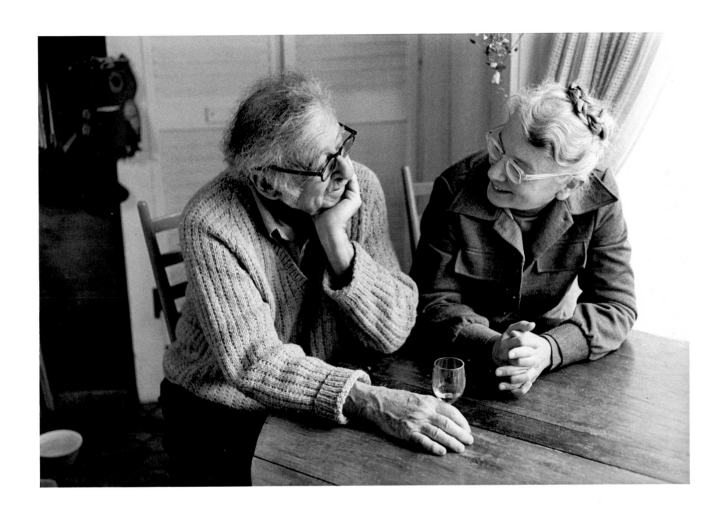

B. A. King *Ralph and Caroline*

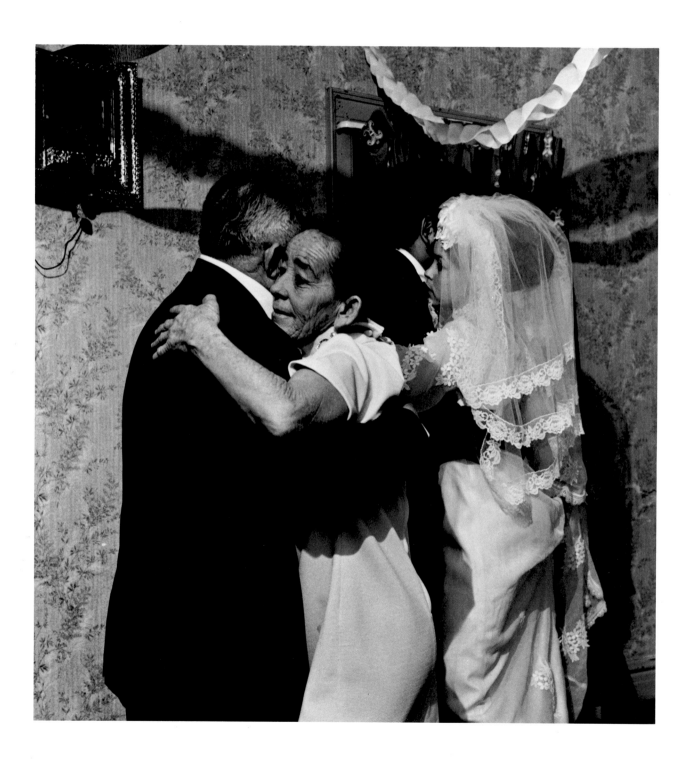

Milton Rogovin *Untitled* (Wedding dance, lower West Side, N.Y.C.)

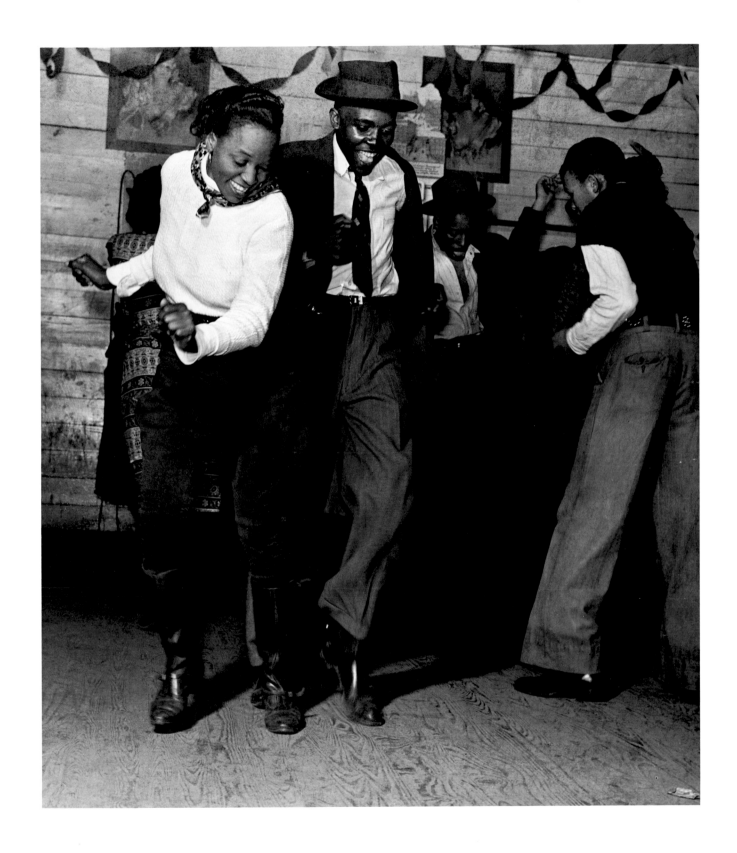

Marion Post Wolcott *Jitterbugging on Saturday night in a juke joint near Marcella Plantation, Clarksdale, Mississippi*

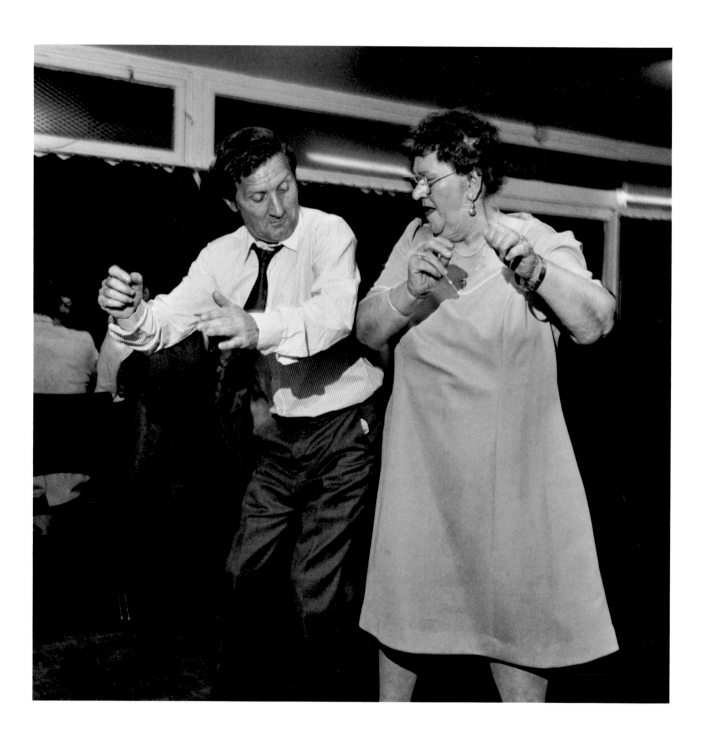

Milton Rogovin *Untitled* (Couple dancing, Scotland)

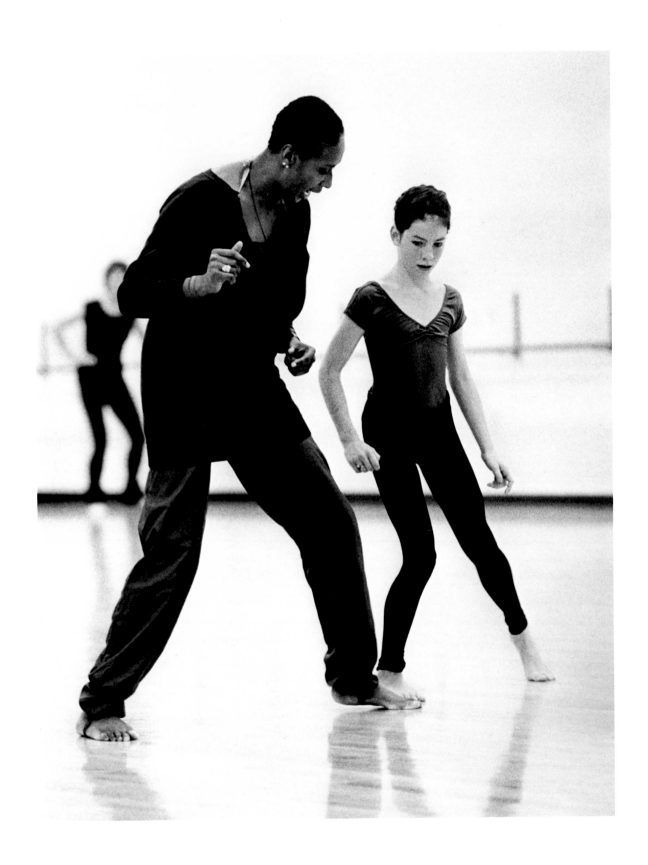

Irene Fertik *Step by Step* (Judith Jamison conducting a workshop at the University of Vermont)

Even here, even now, when the sun had set and the evening star was chastely touching the bosom of the night, there were things to say, things to do. A drink first! What would he drink to—the past, the present, the future? To all of them? He would drink to the life that embraced the three of them! Here, with whitened hair, desires failing, strength ebbing out of him, with the sun gone down, and with only the serenity and the calm warning of the evening star left to him, he drank to Life, to all it had been, to what it was, to what it would be. Hurrah!

SEAN O'CASEY

Laughter, with Affection

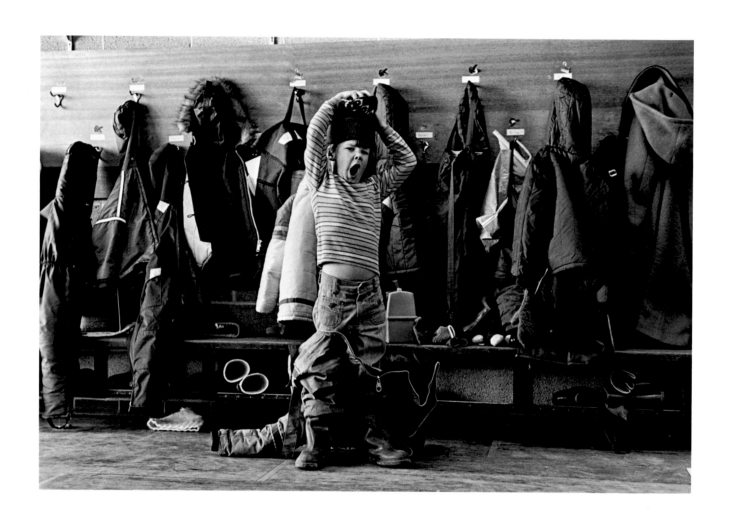

B. A. King *February Morning*

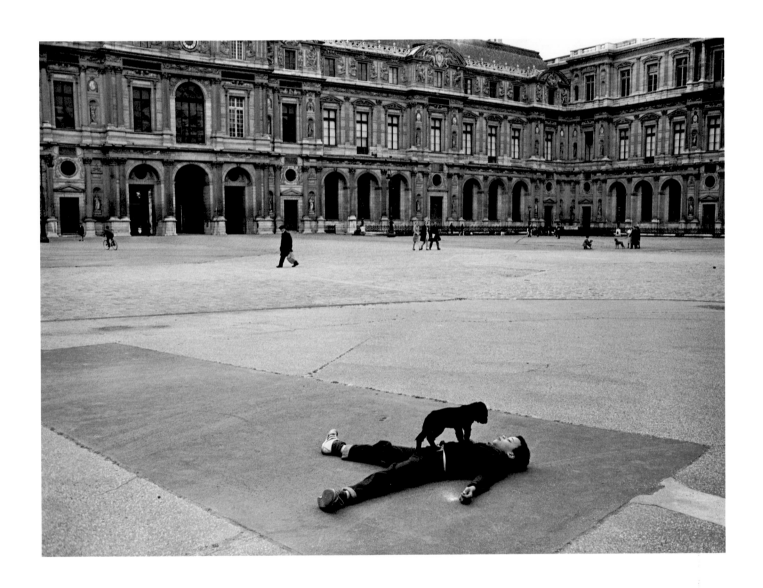

Robert Doisneau *In the Courtyard of the Louvre*

While you and I have lips and voices which

are for kissing and to sing with

who cares if some oneeyed son of a bitch

invents an instrument to measure Spring with?

e.e. cummings

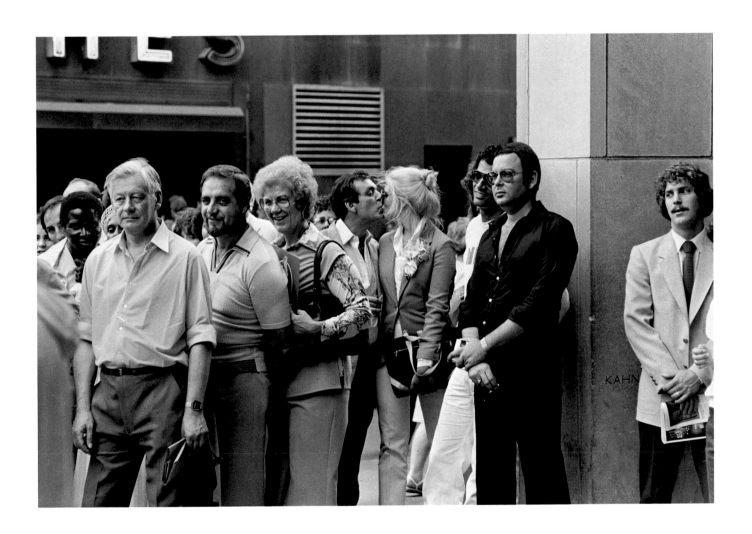

Lou Stoumen *The Kiss, Times Square*

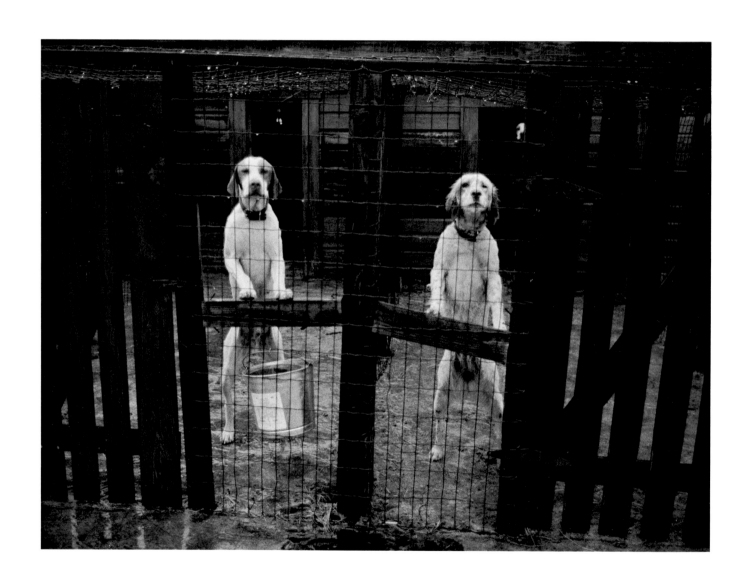

Eleanor Briggs *Inmates*

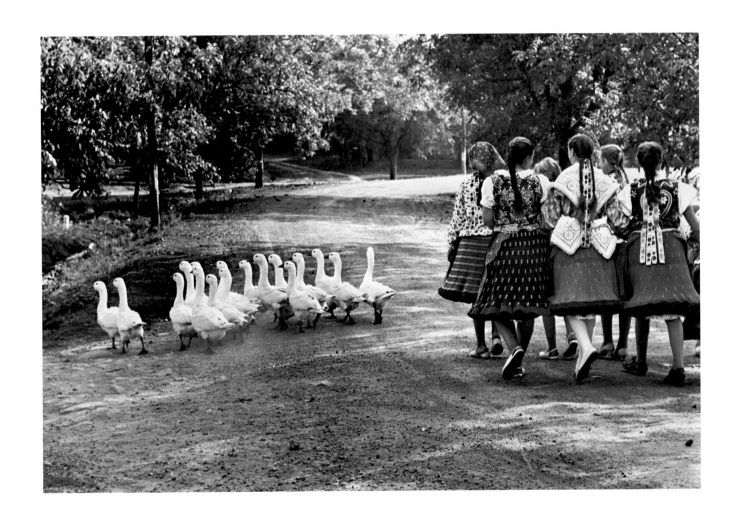

Elliott Erwitt *Hungary*

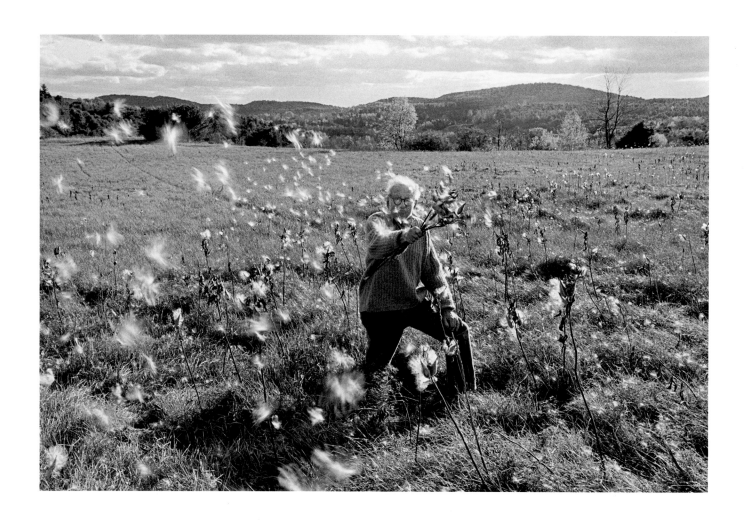

Eleanor Briggs *The Milkweed Deva at Work* (Portrait of Ralph Steiner)

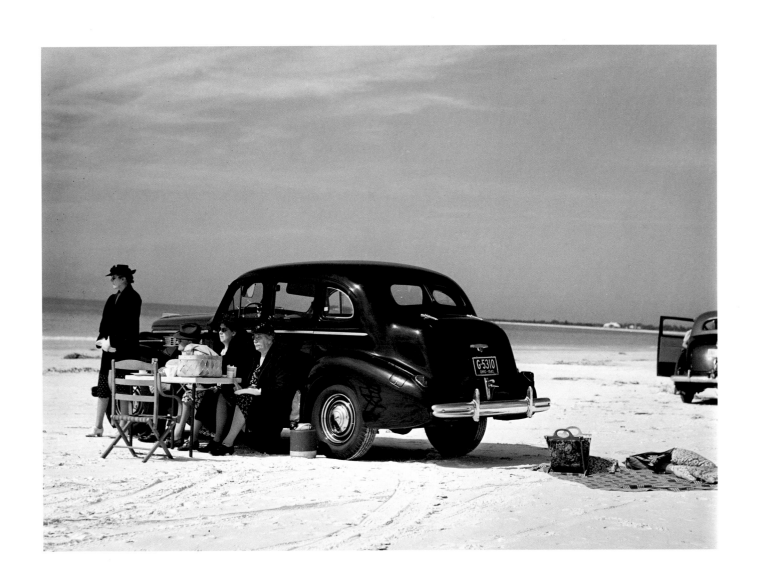

Marion Post Wolcott *Winter visitors picnicking on running board of their car near trailer park, Sarasota, Florida*

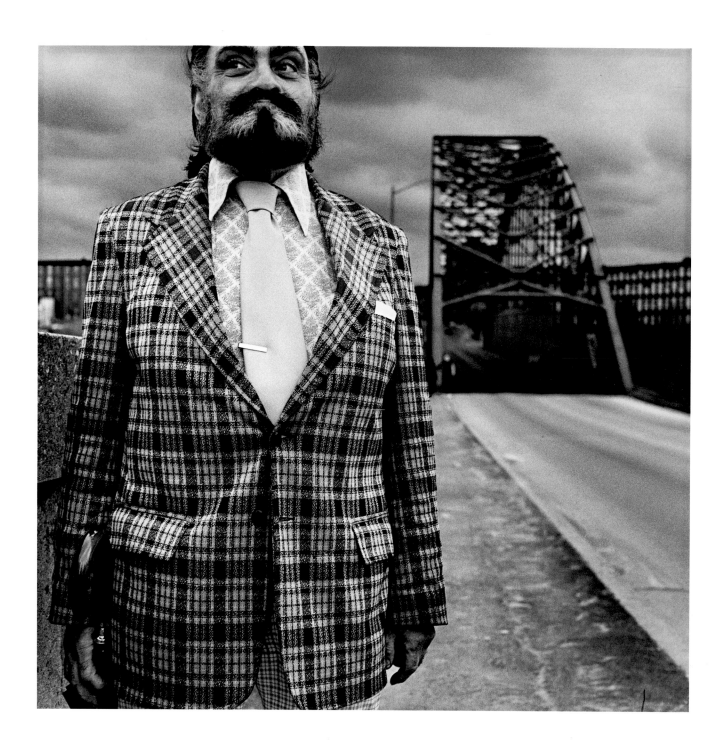

Stephen Lewis *Bob, Manchester*

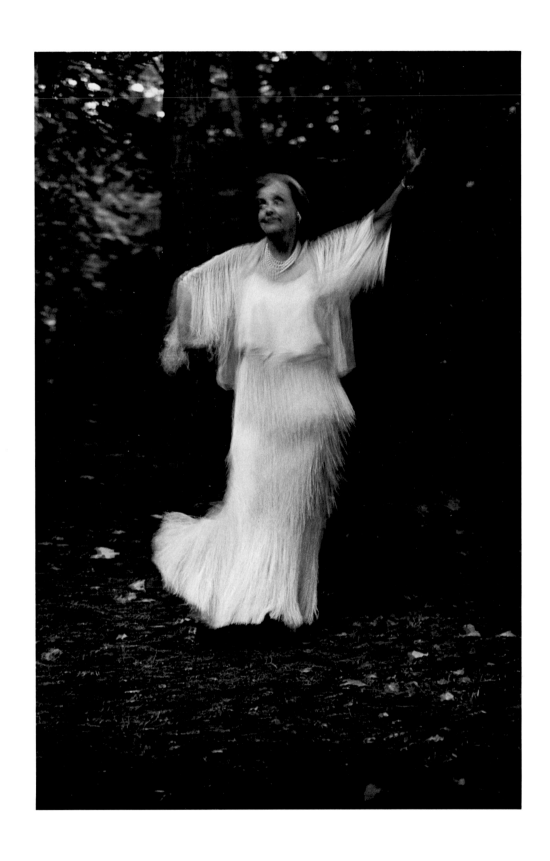

Eleanor Briggs *Mary Dancing*

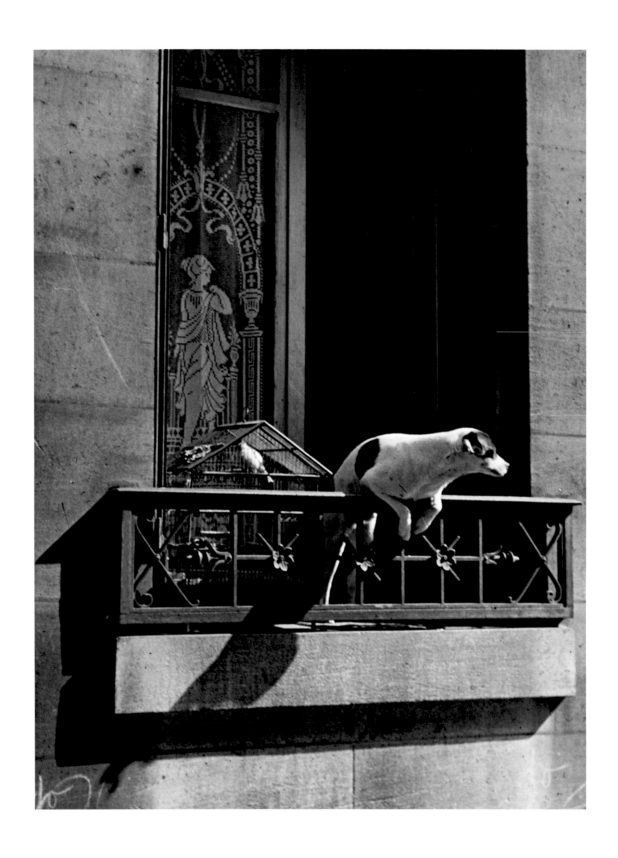

André Kertész *The Concierge's Dog*

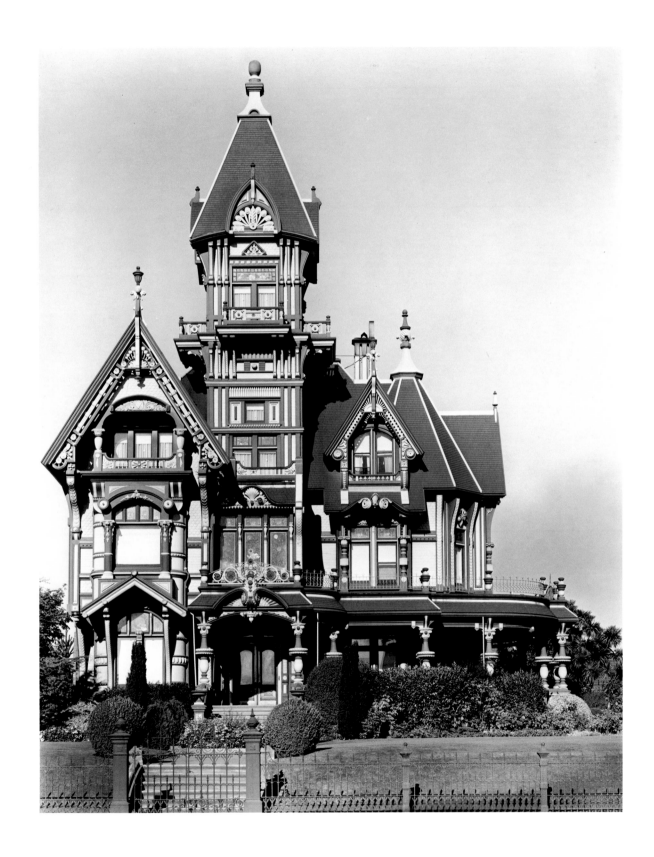

Willard Van Dyke *Carson House, Eureka*

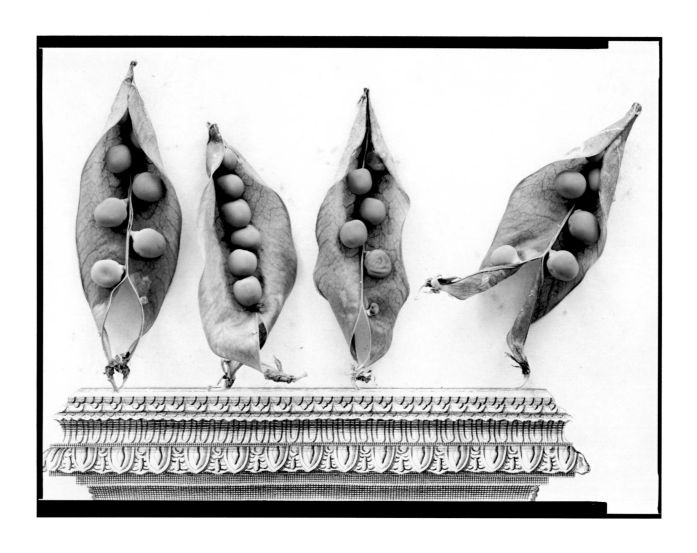

Olivia Parker *Dance*

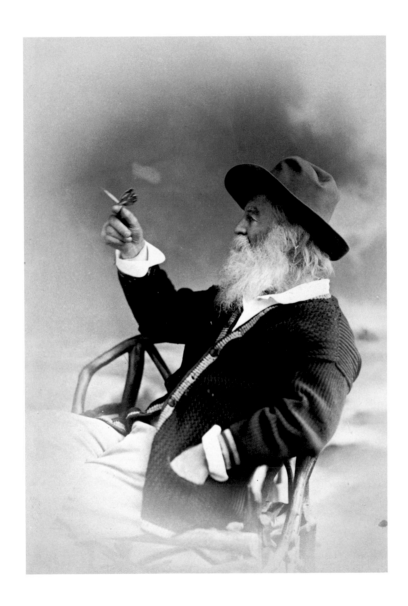

Unknown *Portrait of Walt Whitman (1819–1892)*

The Quiet Eye

Some of these pictures give out their YES easily, even eagerly. Some ask a bit more thinking and opening up of the feeling-valves. We get used to moving so fast that we miss yes-saying things. If we get used to missing instead of feeling, the openings of the heart shrink down.

R.S.

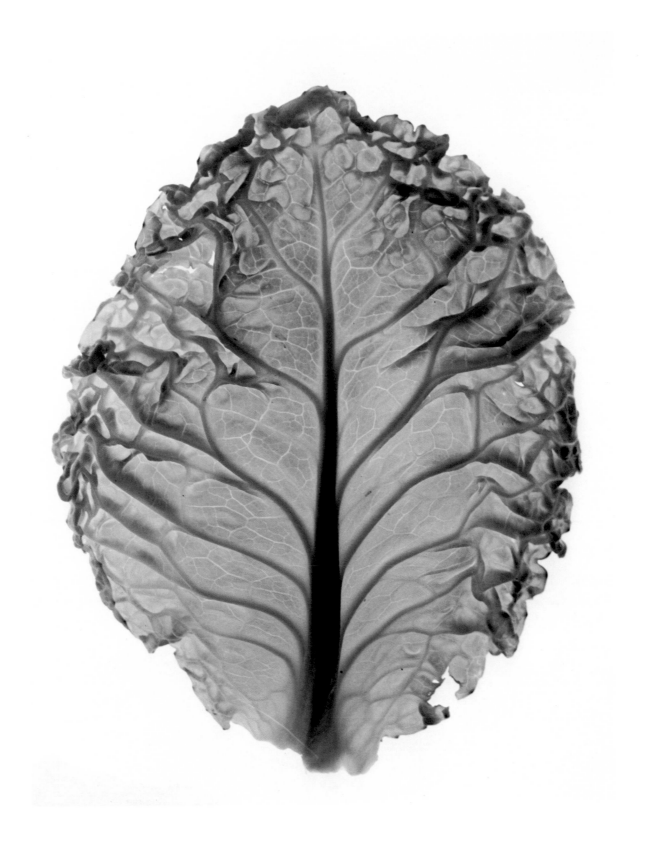

Paul Caponigro *Winthrop, Massachusetts*

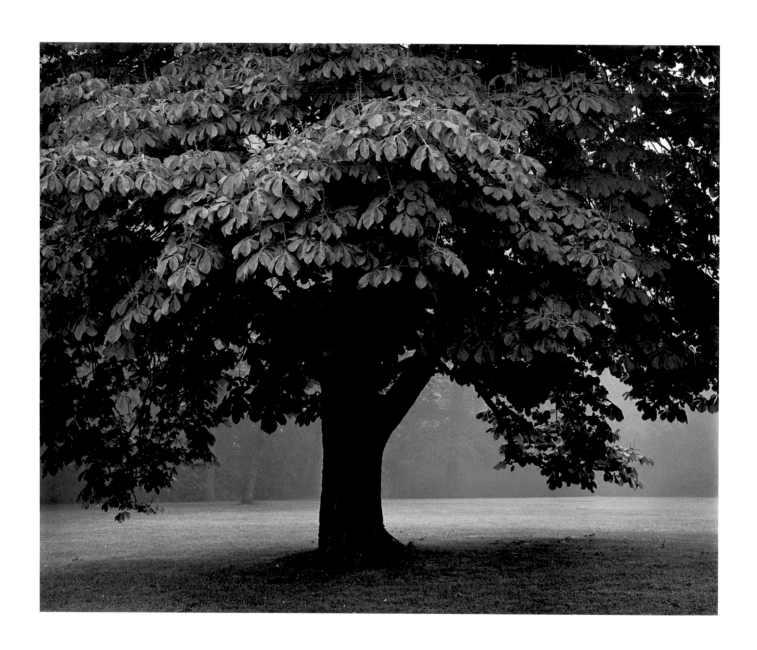

Murray Weiss *Chestnut Tree*

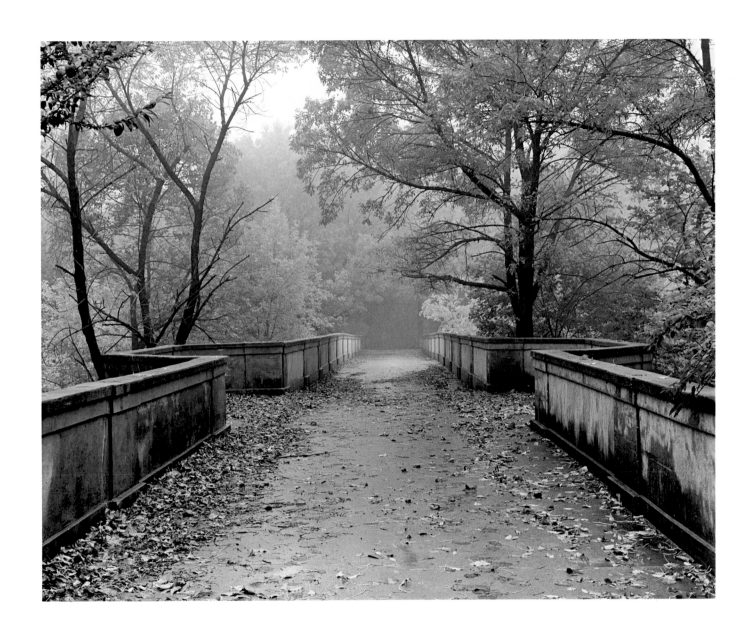

Murray Weiss *Pavillion Bridge*

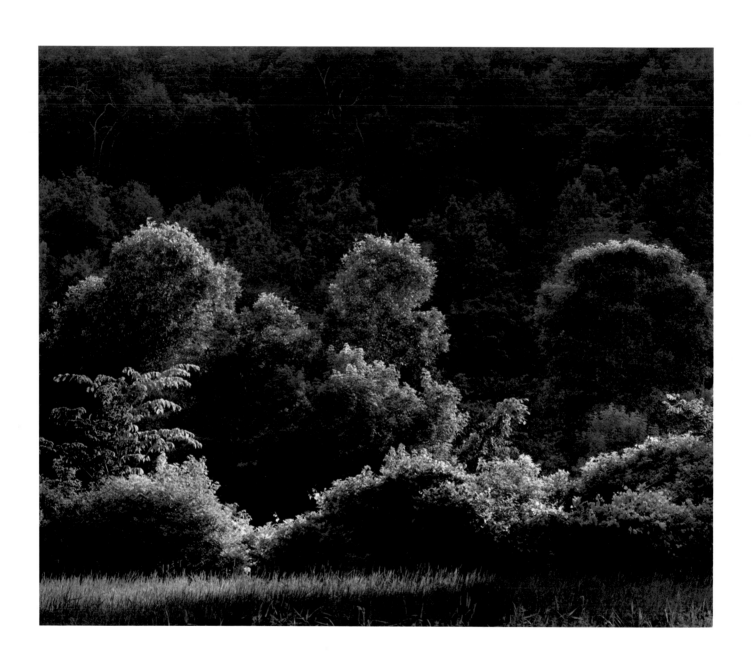

Robert Smith *August Afternoon*

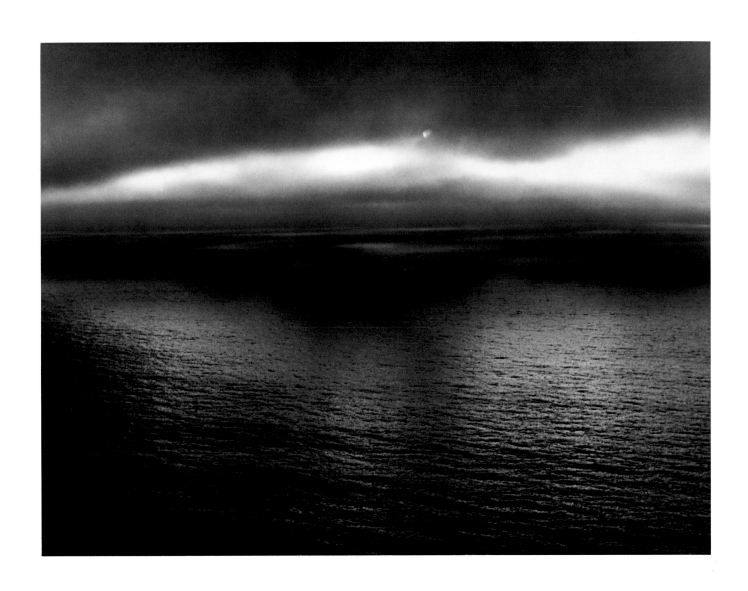

Minor White *Sun over Pacific, Devil's Slide* 85

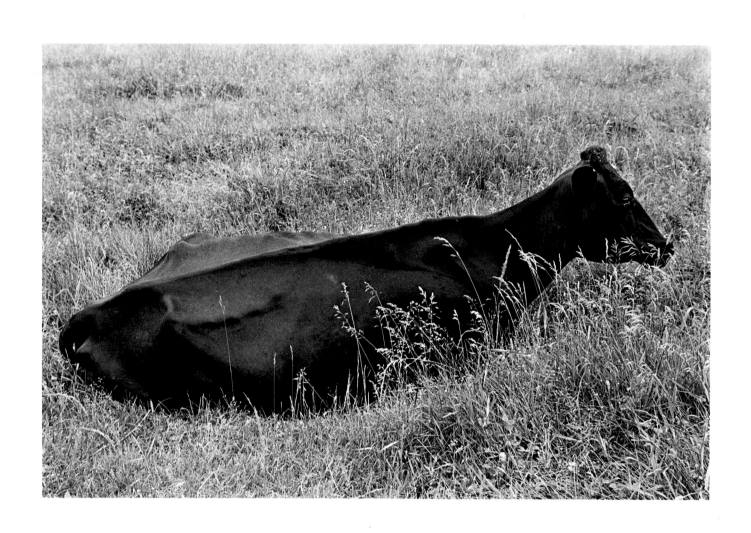

Charles Pratt *Roxbury, Connecticut* (Cow lying down in field)

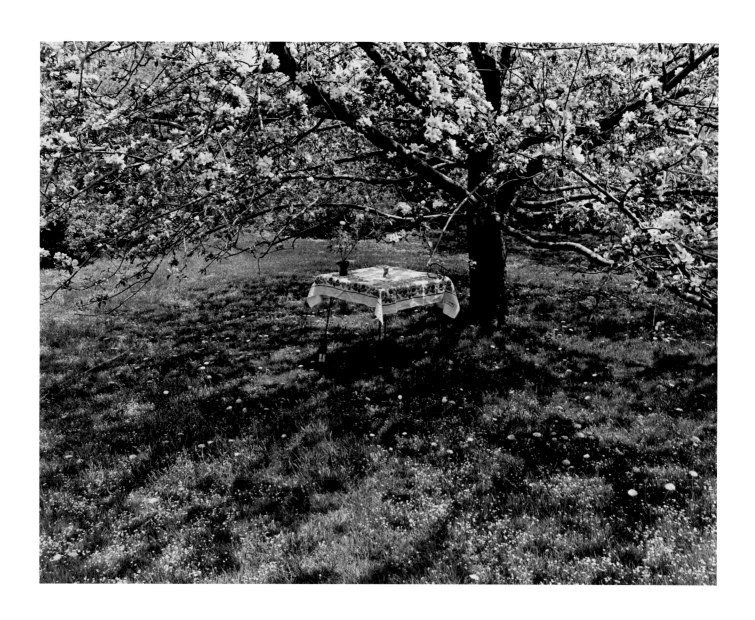

Charles Pratt *Roxbury, Connecticut* (Table under the trees)

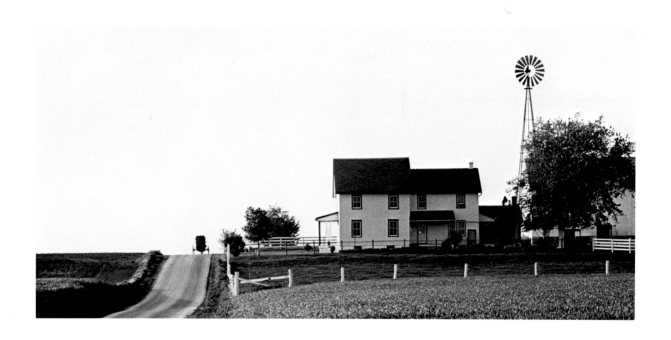

George A. Tice *Buggy, Farmhouse and Windmill*, from *The Amish Portfolio*

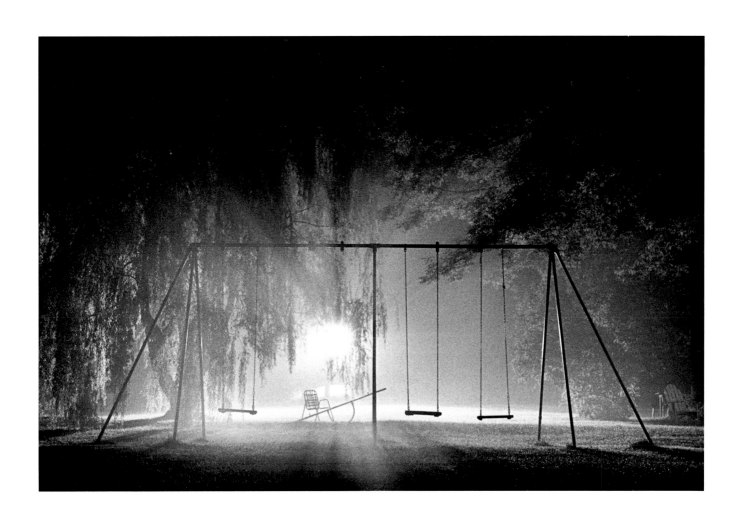

Michael Kenna *Swings, Catskill Mountains, N.Y., U.S.A.*

To express what one wishes, one must look

at things with enough attention to discover in them

what has never been seen before.

GUSTAV FLAUBERT

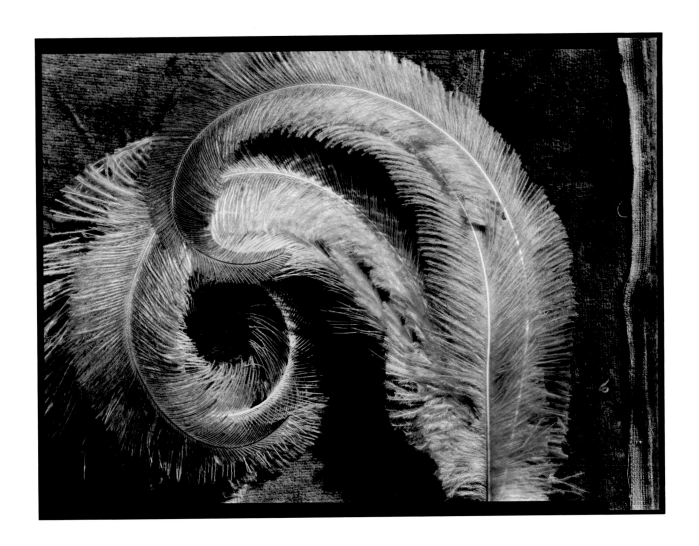

Olivia Parker *Vicksburg Feather*

92

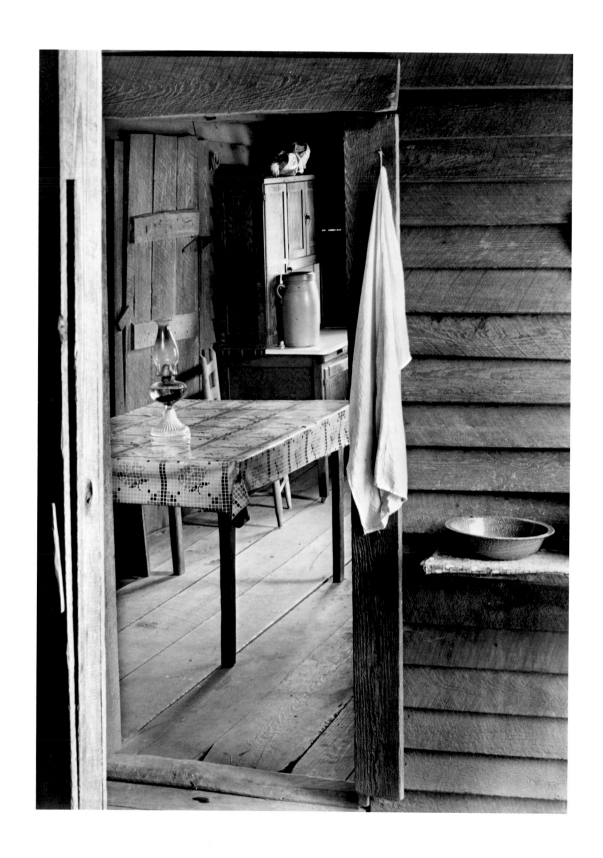

Walker Evans *Burrow's Kitchen, Hale County, Alabama*

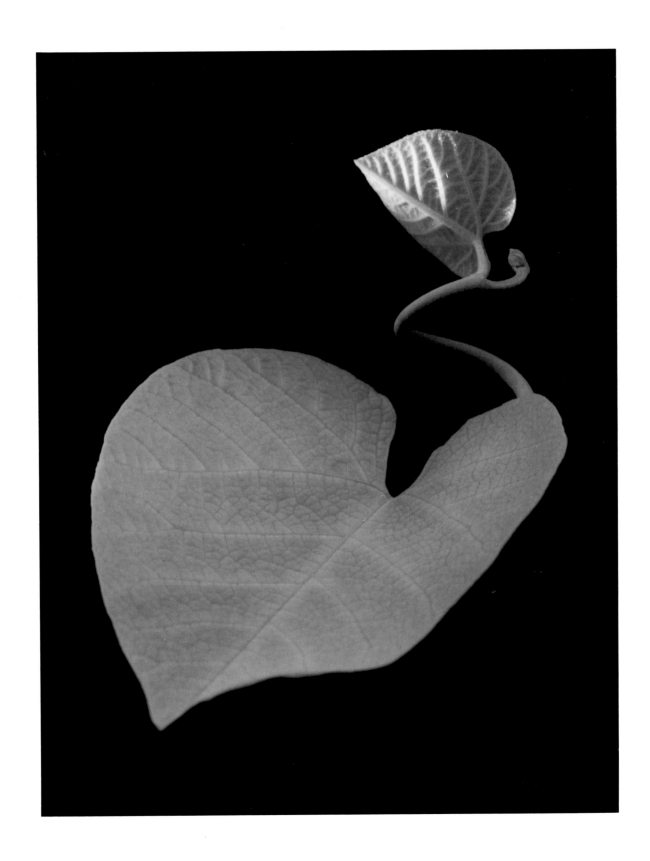

Paul Caponigro *Brewster, New York*

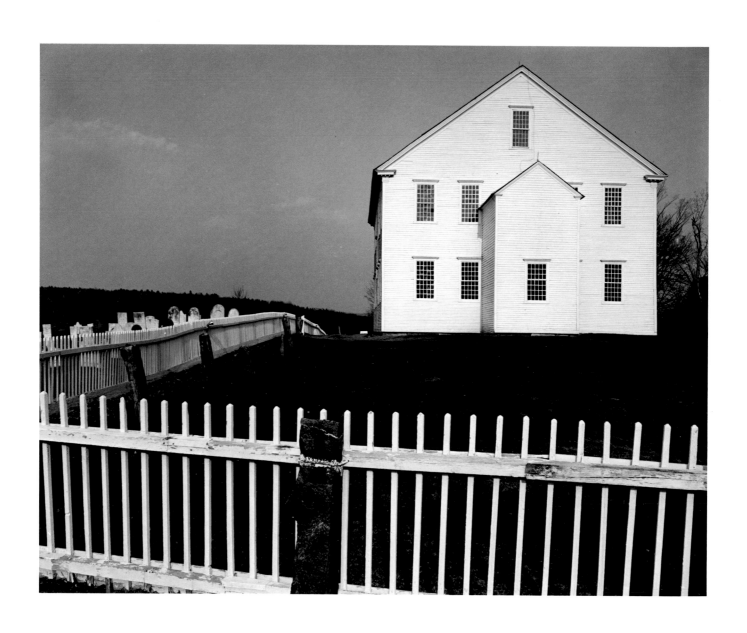

Robin Brown *Rockingham Meeting House*

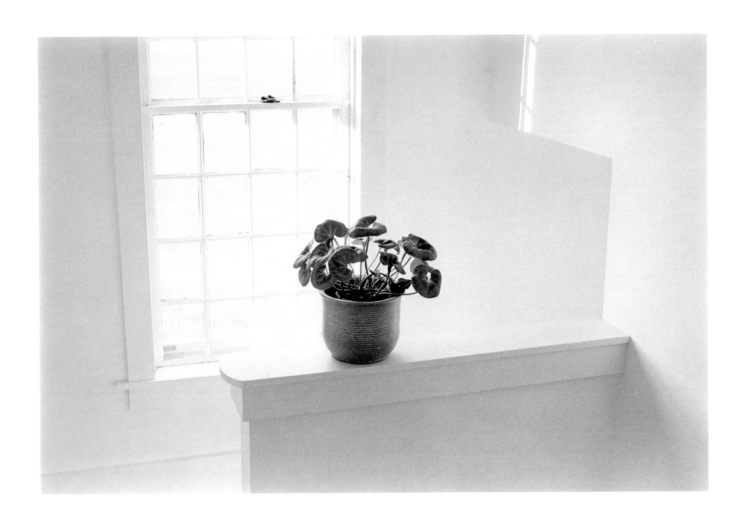

John Sheldon *Interior, Plainfield, N.H.*

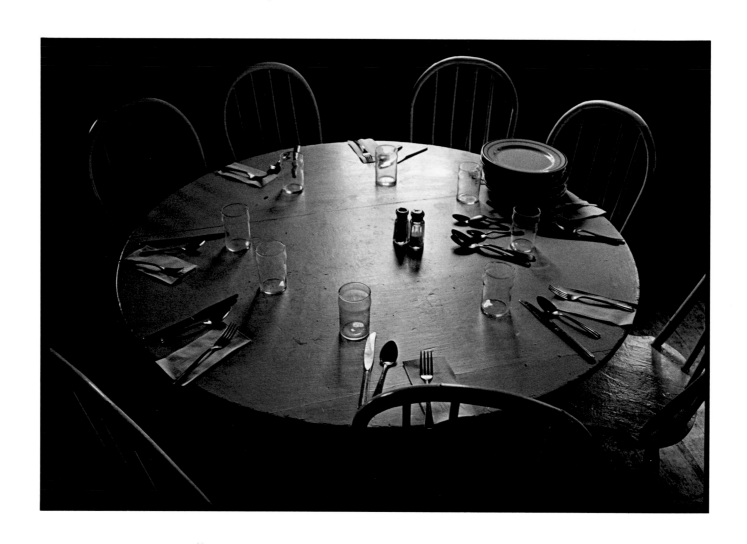

B. A. King *Grace*

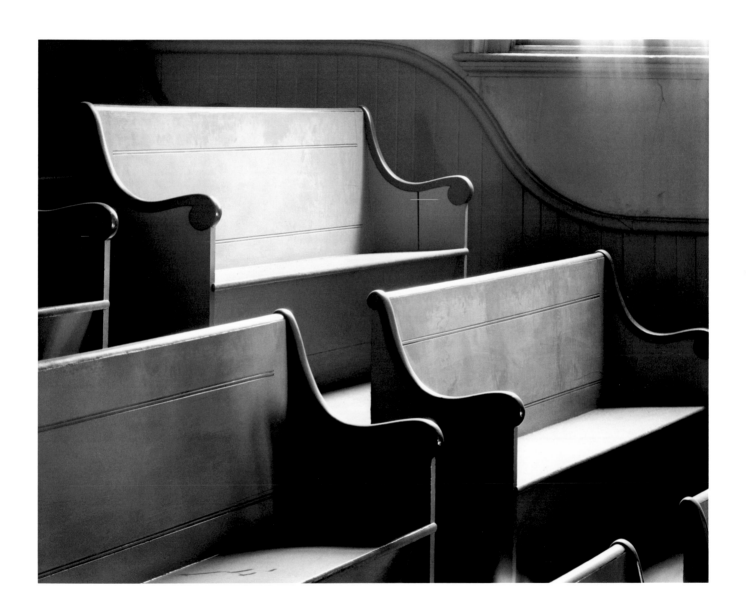

William Clift *Balcony Benches, Old City Hall, Boston*

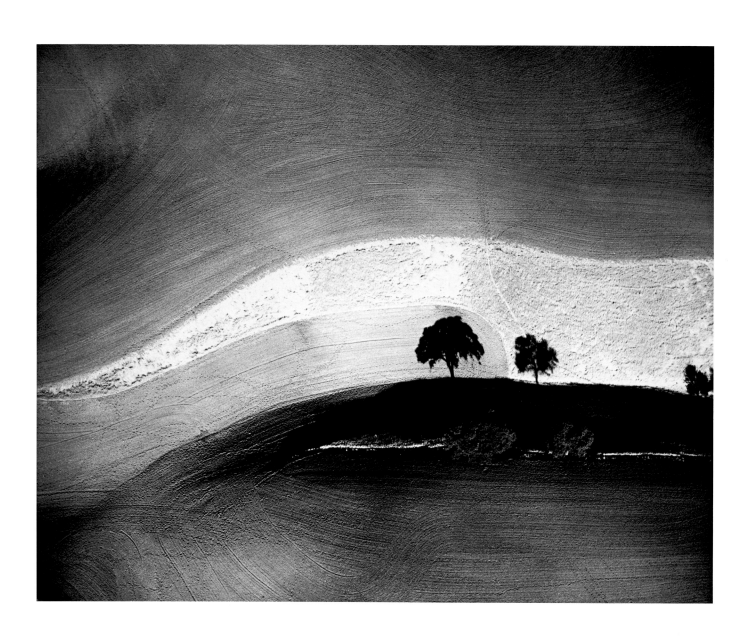

William A. Garnett *Two Trees on Hill with Shadows, Paso Robles, California*

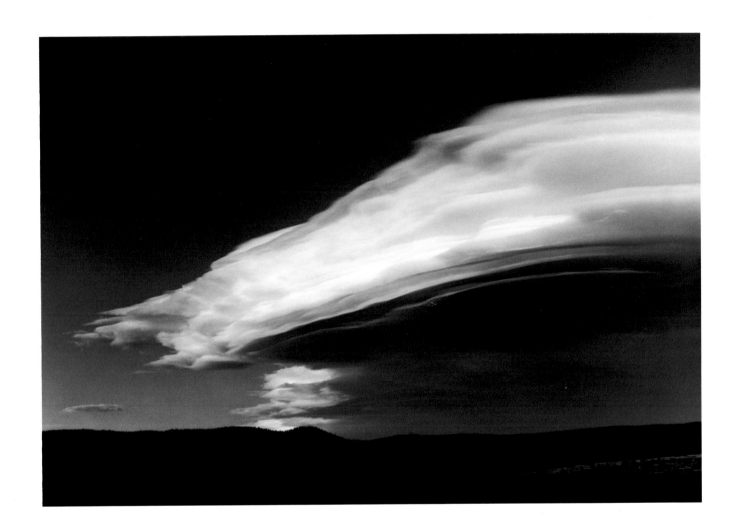

Arthur Lazar *Pecos Cloud, New Mexico*

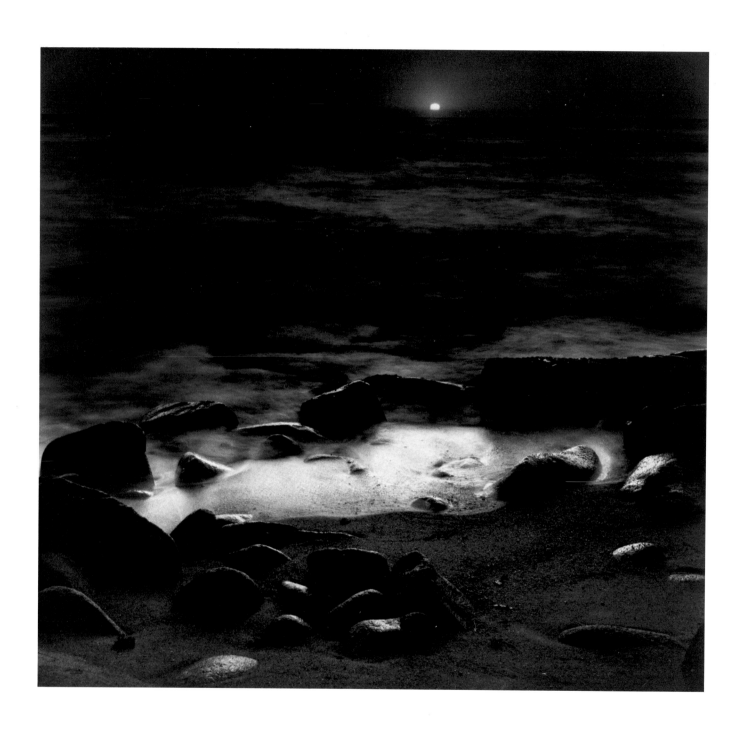

Wynn Bullock *The Shore*

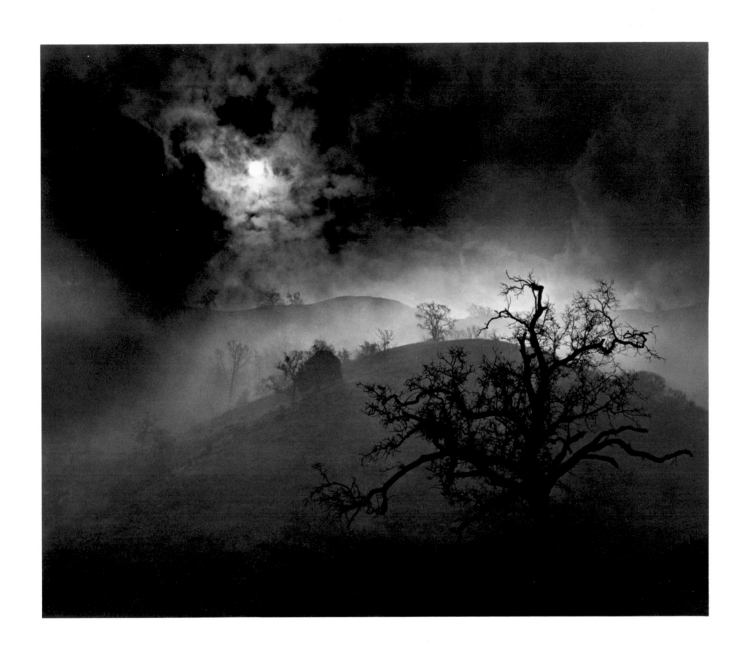

Wynn Bullock *Stark Tree*

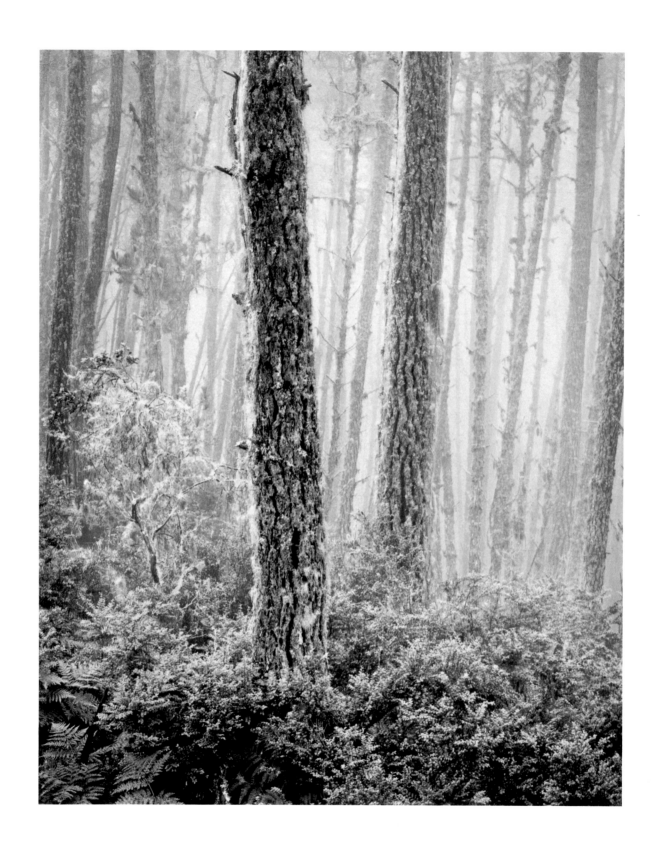

Wynn Bullock *The Forest*

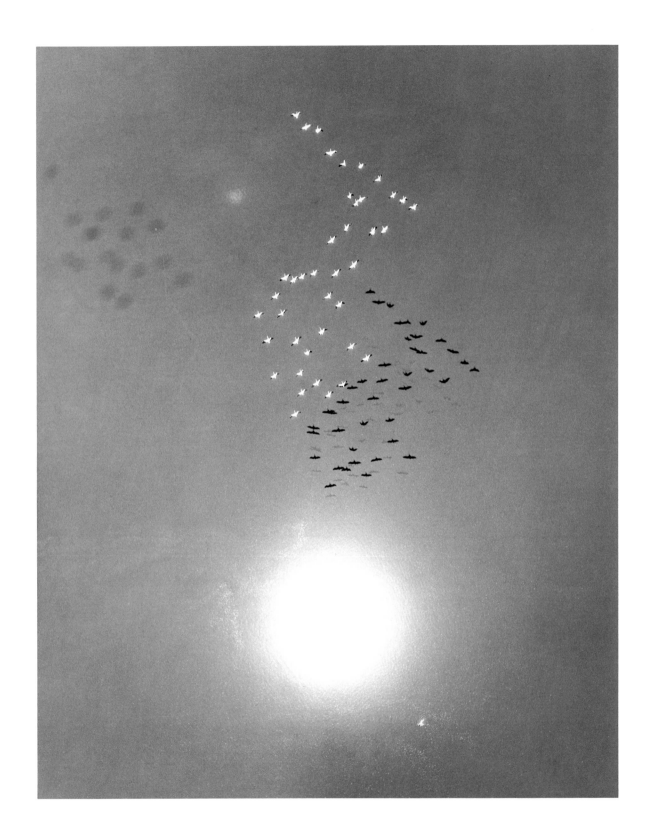

William A. Garnett *Snow Geese with Reflection of the Sun over Buena Vista Lake, California* 107

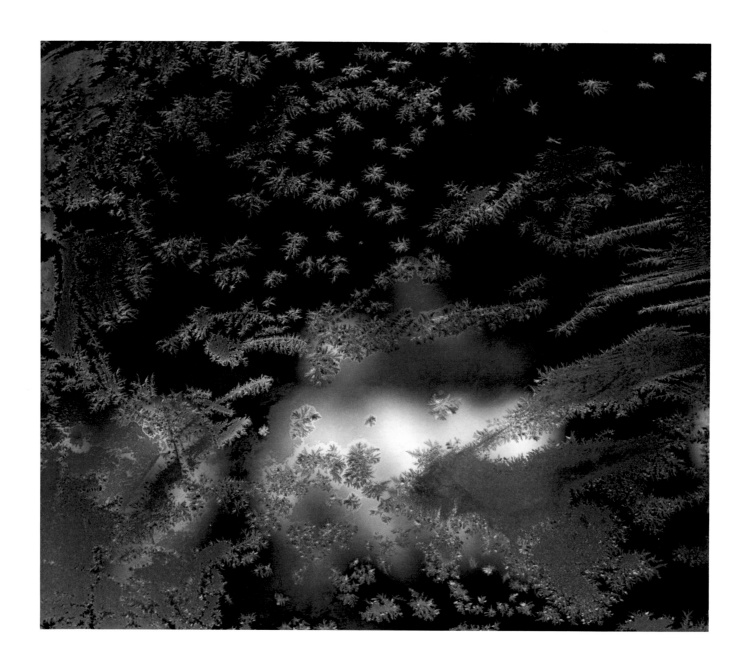

Paul Caponigro *Frosted Window*, from *Portfolio II*

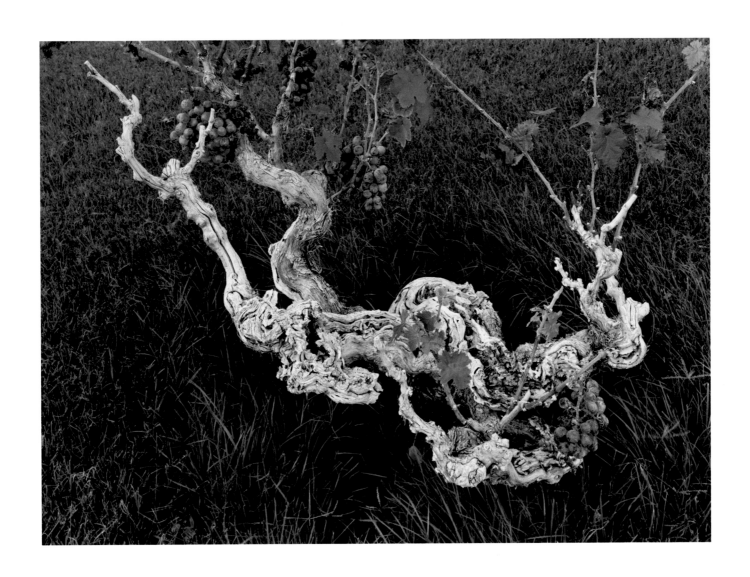

Paul Caponigro *Tecate, Mexico*

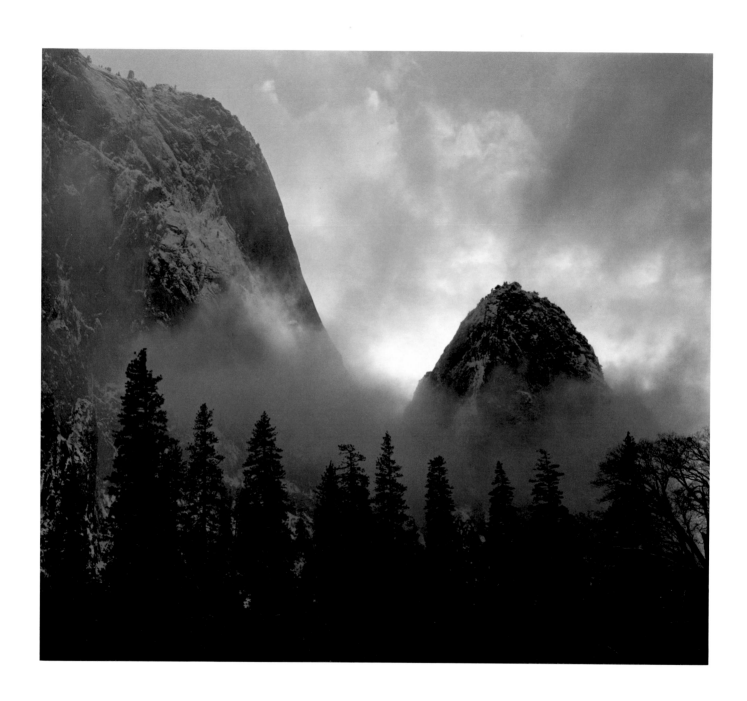

Paul Caponigro *Yosemite, California*

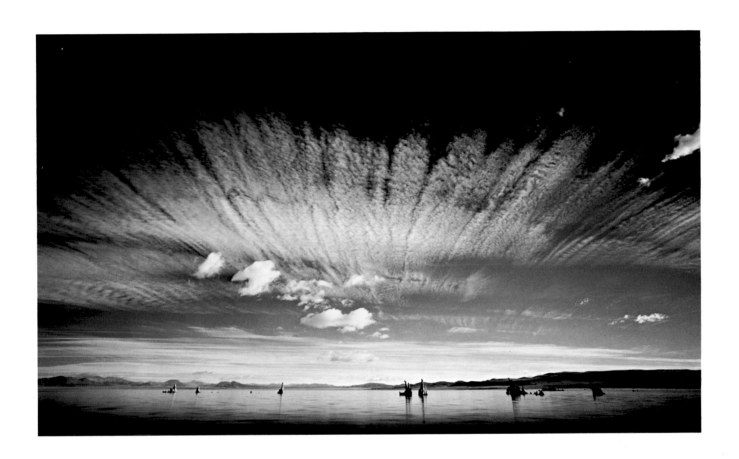

Robert Dawson *Untitled, #7* from the *Mono Lake Series* 111

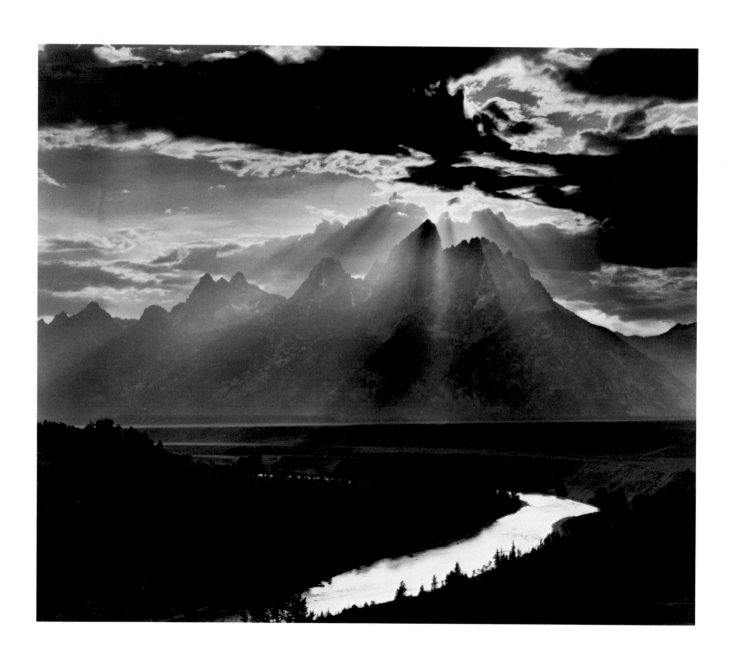

112 Minor White *Grand Tetons, Wyoming*

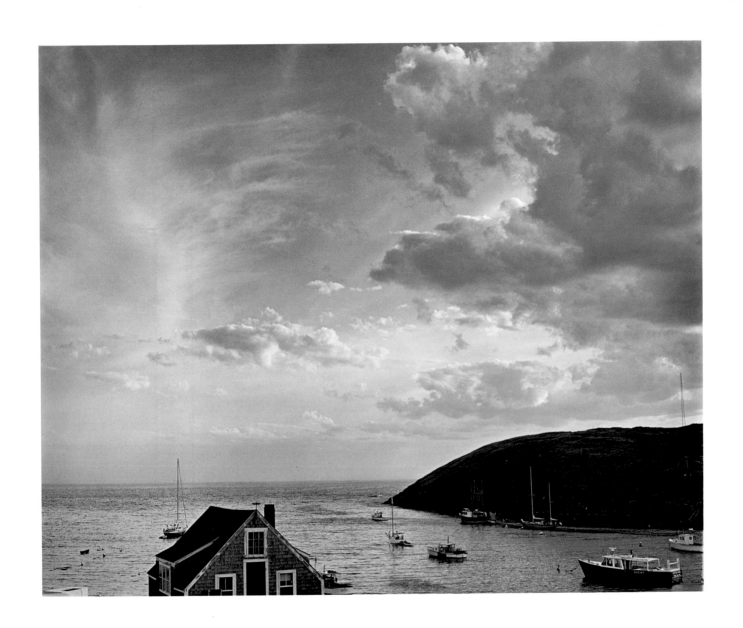

Murray Weiss *Monhegan Harbor*

The Colors of the Earth

If there is no God, why isn't the universe dark brown?

LOUISE BOGAN

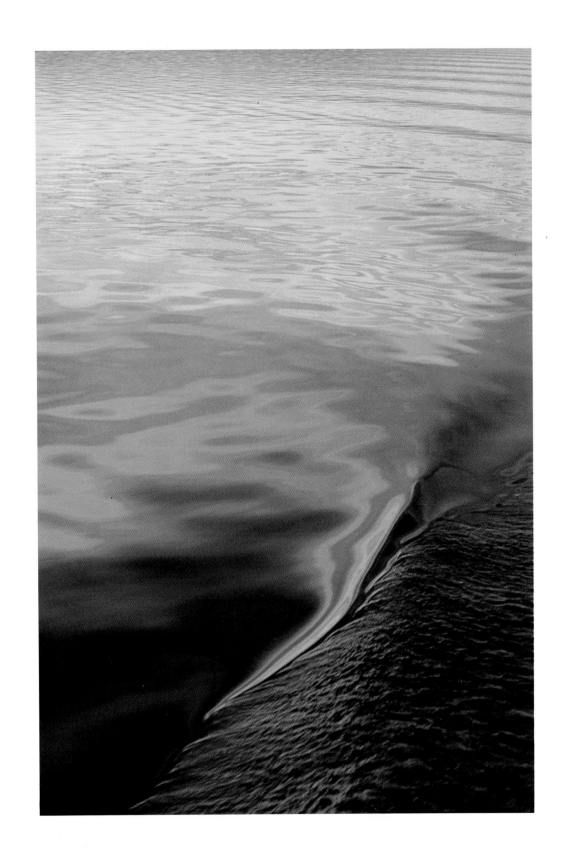

Barbara Rogasky *Fire Wake*

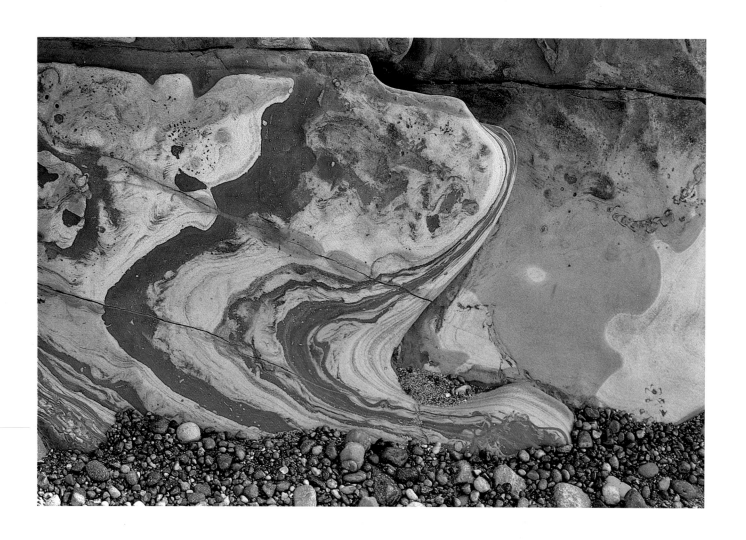

Douglas Frantz *Rocks, Point Lobos, California*

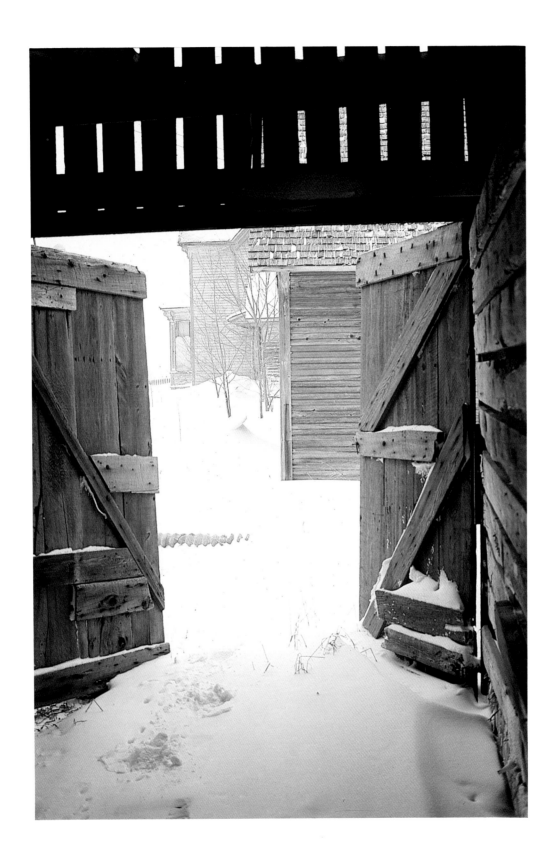

Douglas Frantz *Farm Buildings, near Traverse City, Michigan* 119

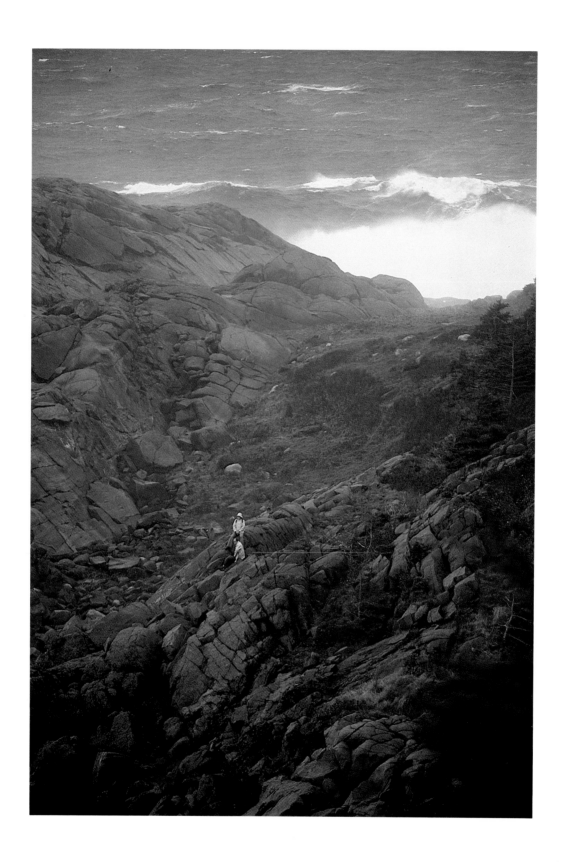

Richard Farrell *Storm Watchers*

Ah! my dear comrades, let us crazy ones take delight in our eyesight in spite of everything, yes, let's! Alas, nature takes it out of the animal, and our bodies are despicable and sometimes a heavy burden. But it has been like that ever since Giotto, that man with his poor health. Ah! and what a feast for the eyes all the same, and what a smile is that toothless smile of the old lion Rembrandt, with a piece of white cloth around his head, his palette in his hand!

VINCENT VAN GOGH

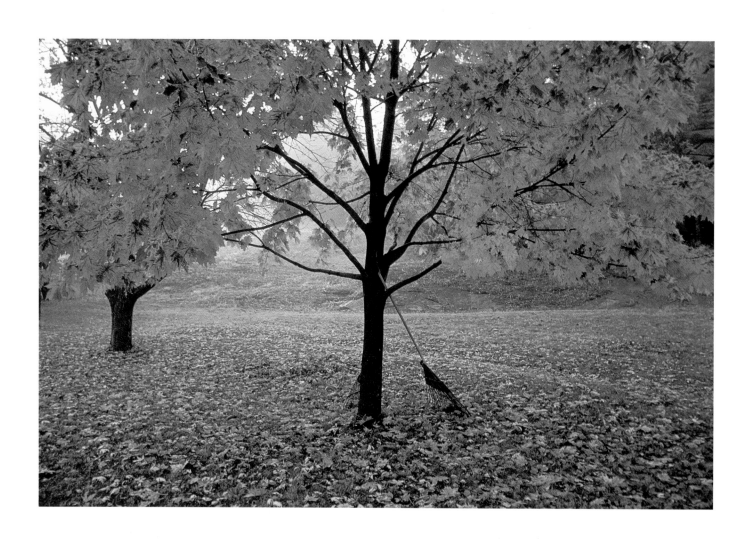

Dewitt Jones *Tree with Rake*

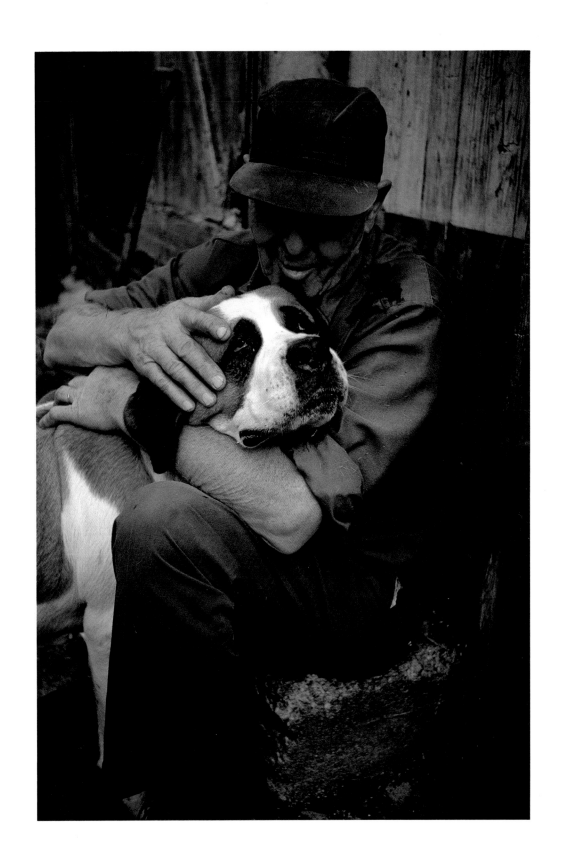

Dewitt Jones *Farmer with St. Bernard*

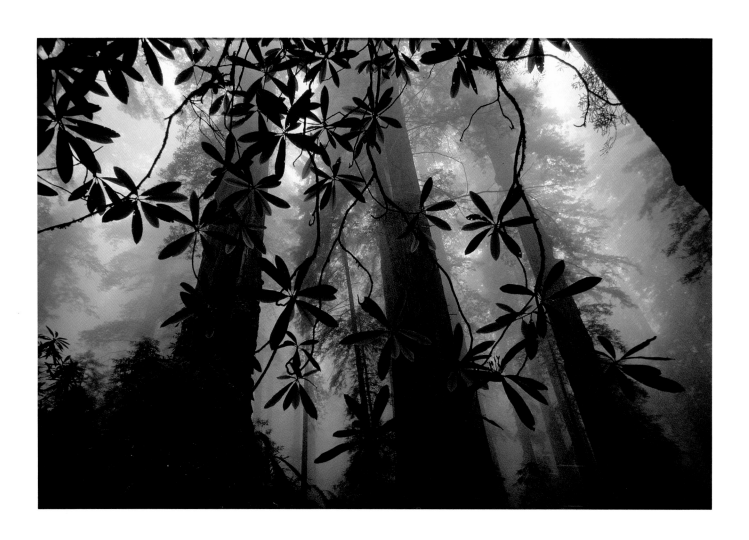

Dewitt Jones *Redwoods and Rhododendrons*

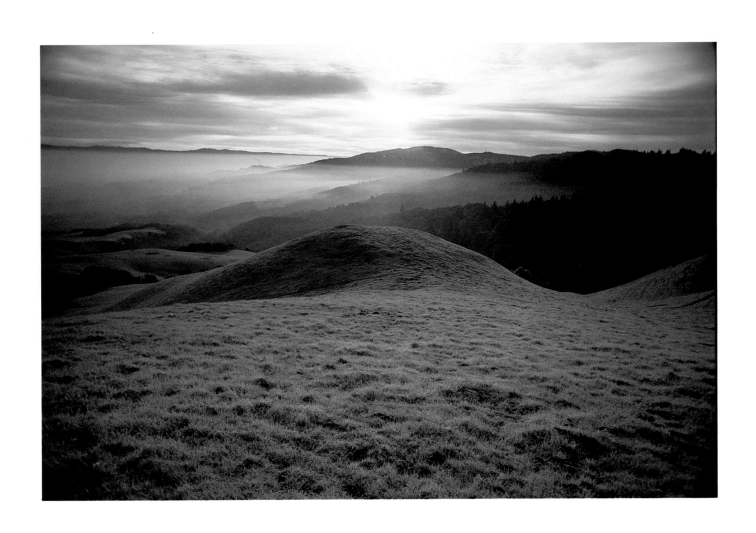

Dewitt Jones *Landscape*

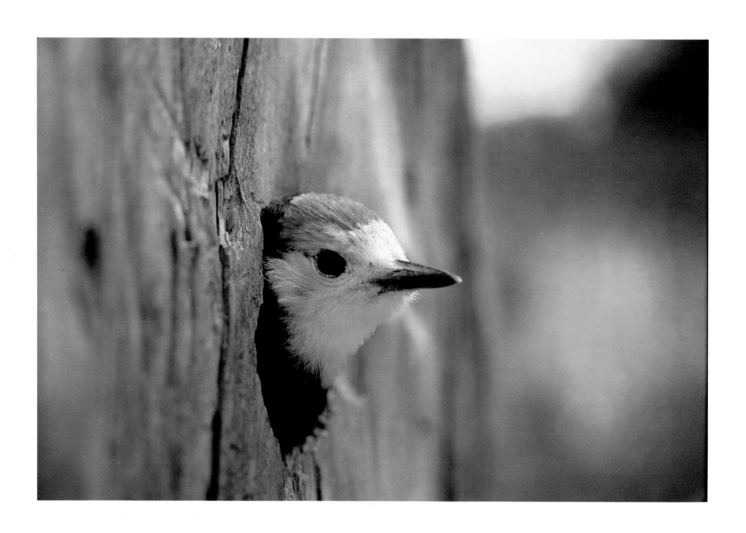

Dewitt Jones *Woodpecker*

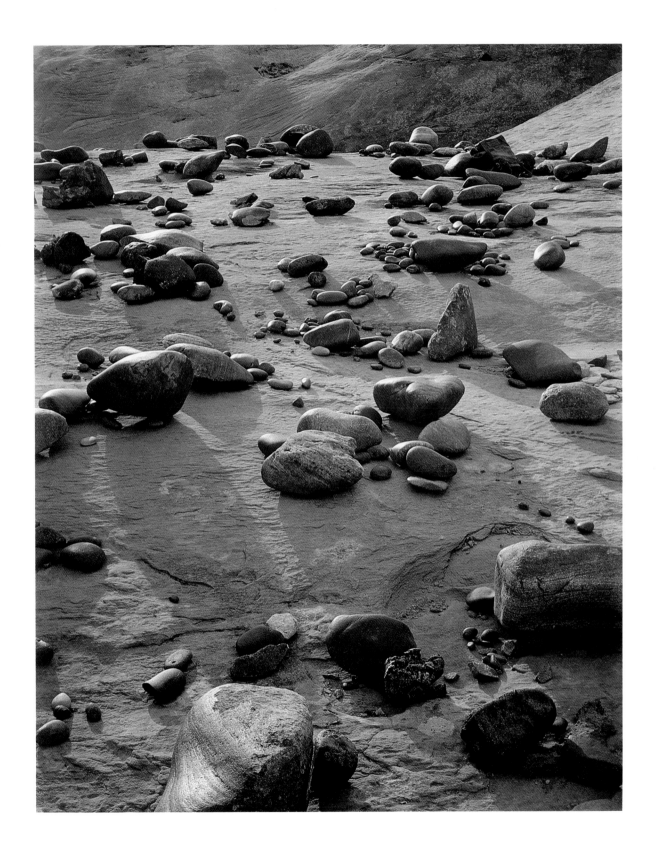

Eliot Porter *Balanced Rock Canyon, Glen Canyon, Utah*

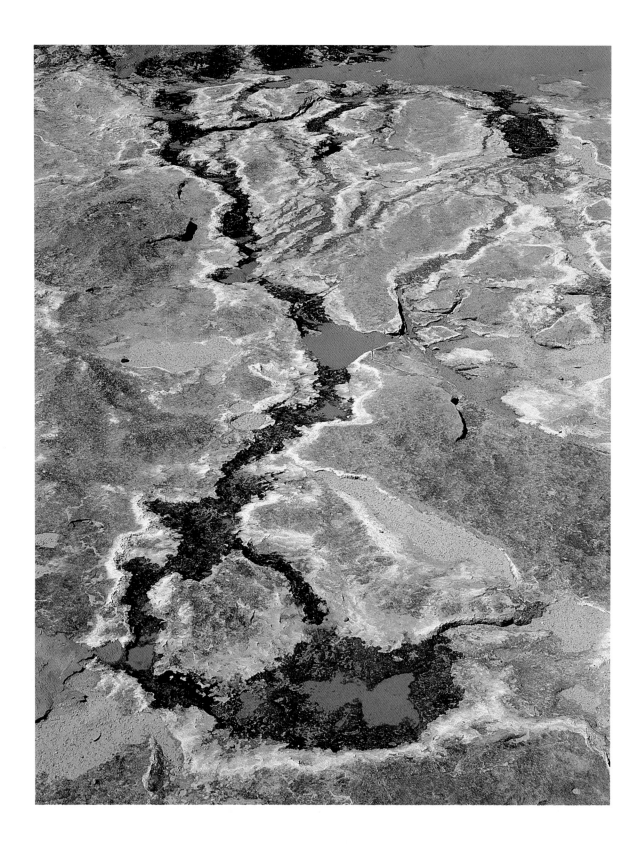

Eliot Porter *Water Stain, Music Temple, Glen Canyon*

Glory be to God for dappled things—

For skies of couple-color as a brinded cow;

For rose-moles all in stipple upon trout that swim;

Fresh-firecoal chestnut-falls; finches' wings;

Landscape plotted and pieced—fold, fallow, and plough;

And all trades, their gear and tackle and trim.

All things, counter, original, spare, strange;

Whatever is fickle, freckled (who knows how?)

With swift, slow; sweet, sour; adazzle, dim;

He fathers-forth whose beauty is past change:

Praise Him.

GERARD MANLEY HOPKINS

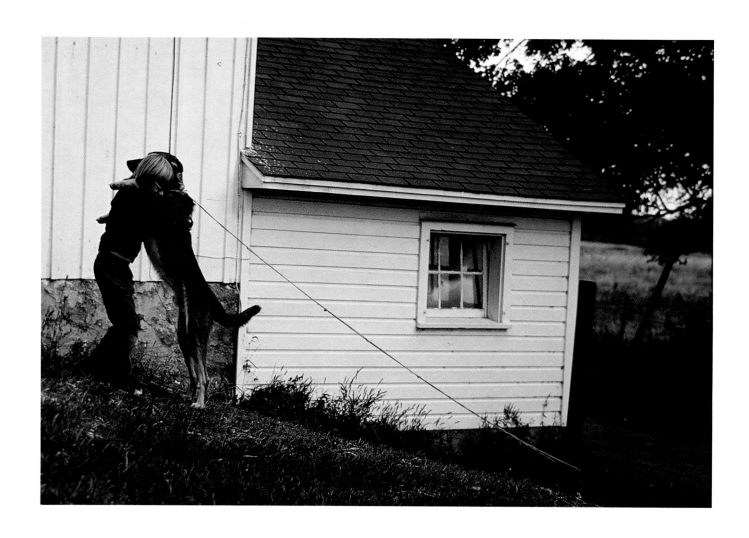

Ernst Haas *Untitled* (Boy with dog)

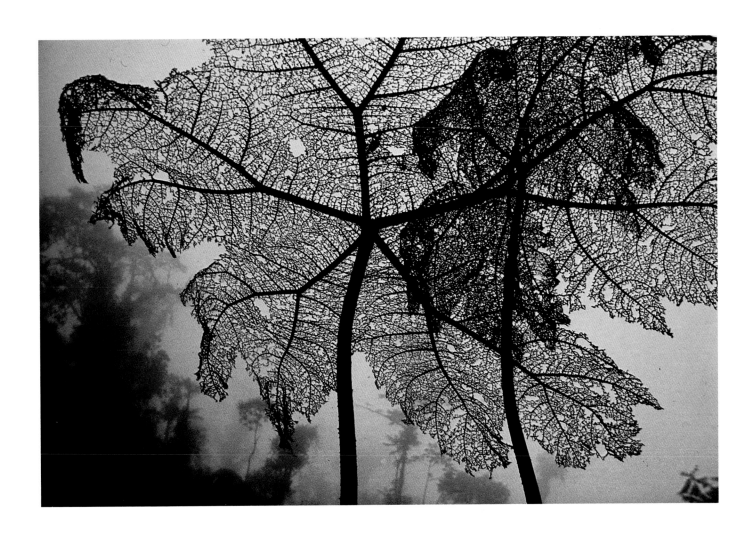

Ernst Haas *Untitled* (Skeleton leaves, Ecuador)

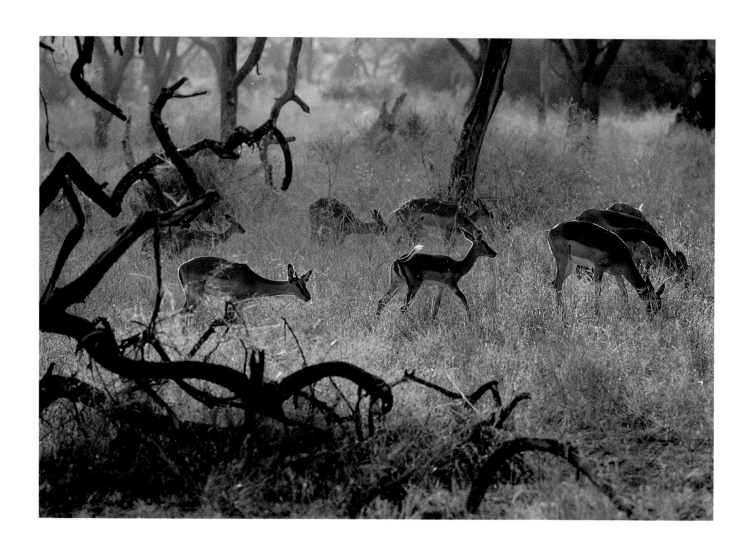

136 Ernst Haas *Untitled* (Deer in Africa)

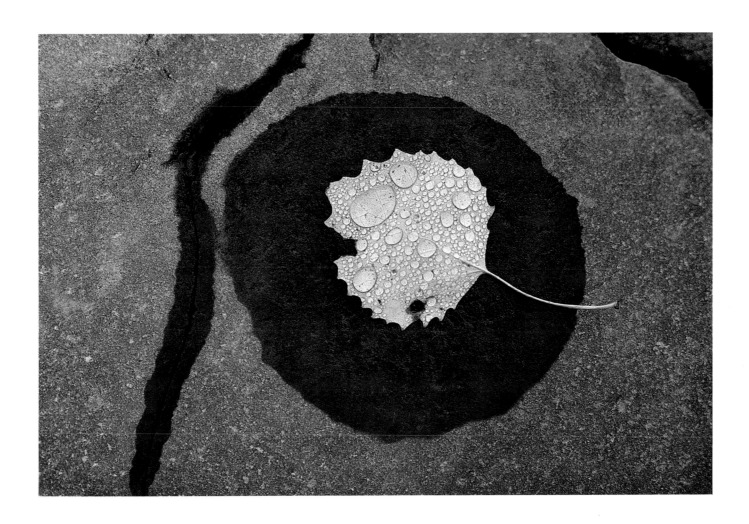

Ernst Haas *Untitled* (Wet leaf)

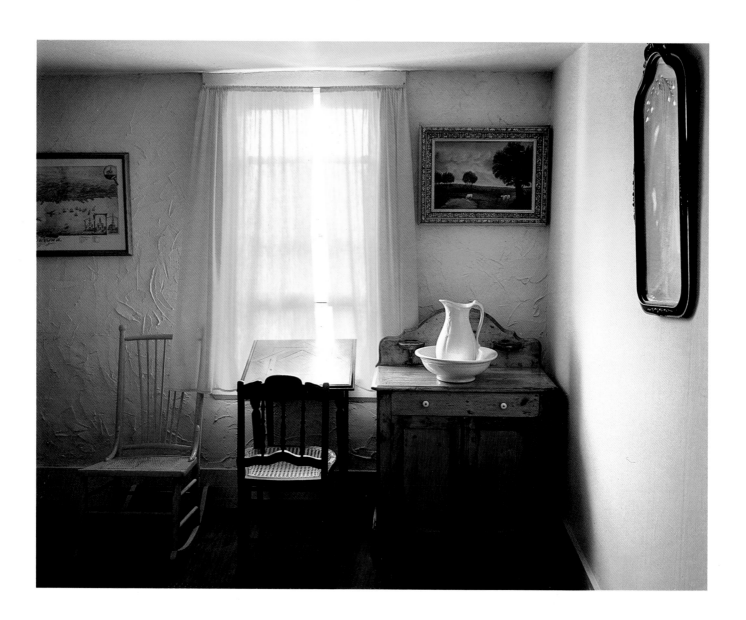

Joel Meyerowitz *The Yellow Room*

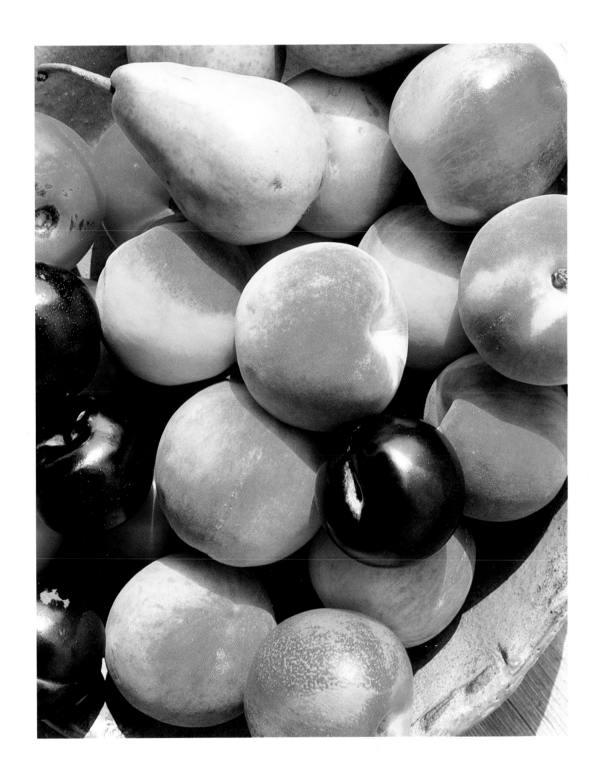

Joel Meyerowitz *Fruit*

139

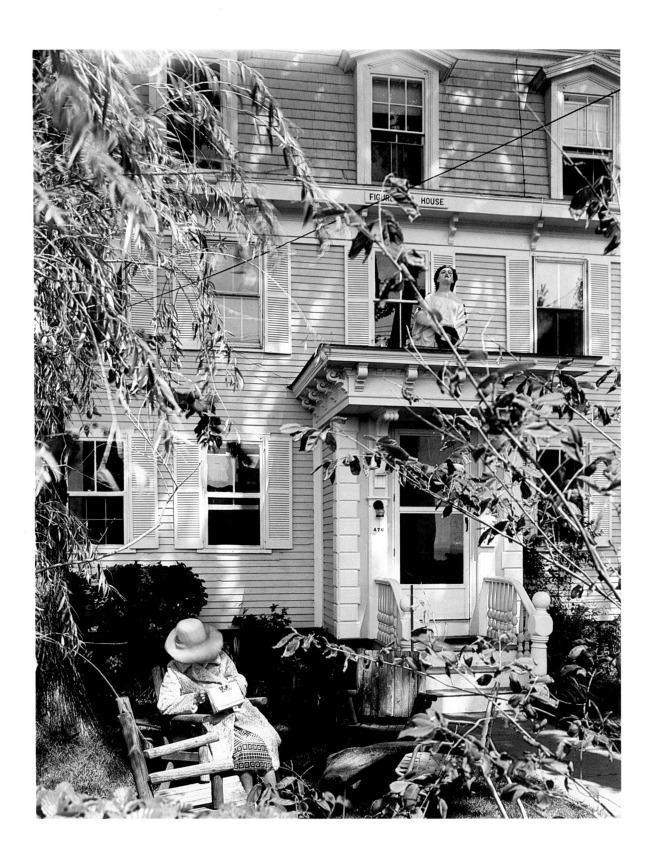

Joel Meyerowitz *Reading*

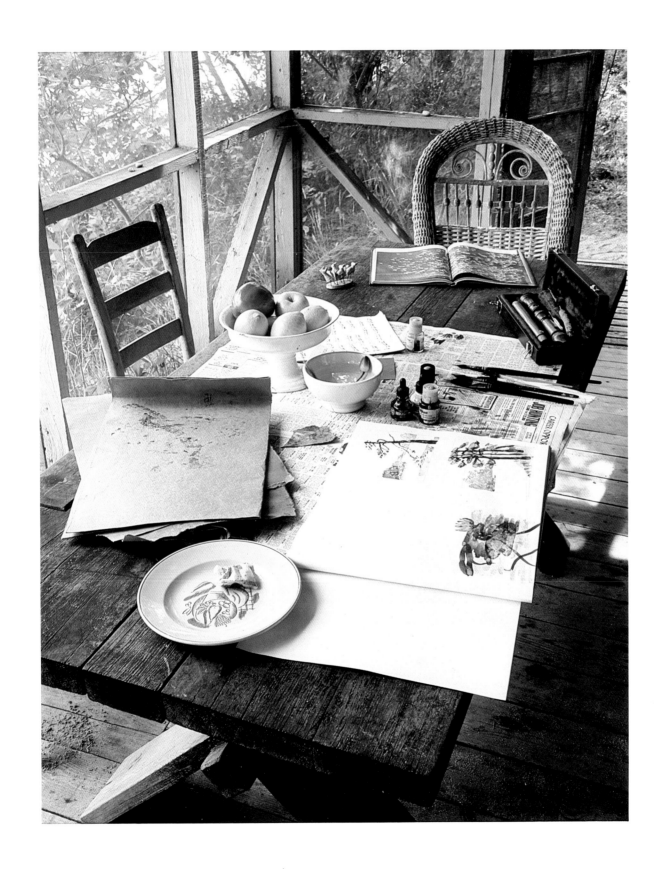

Joel Meyerowitz *The Table*

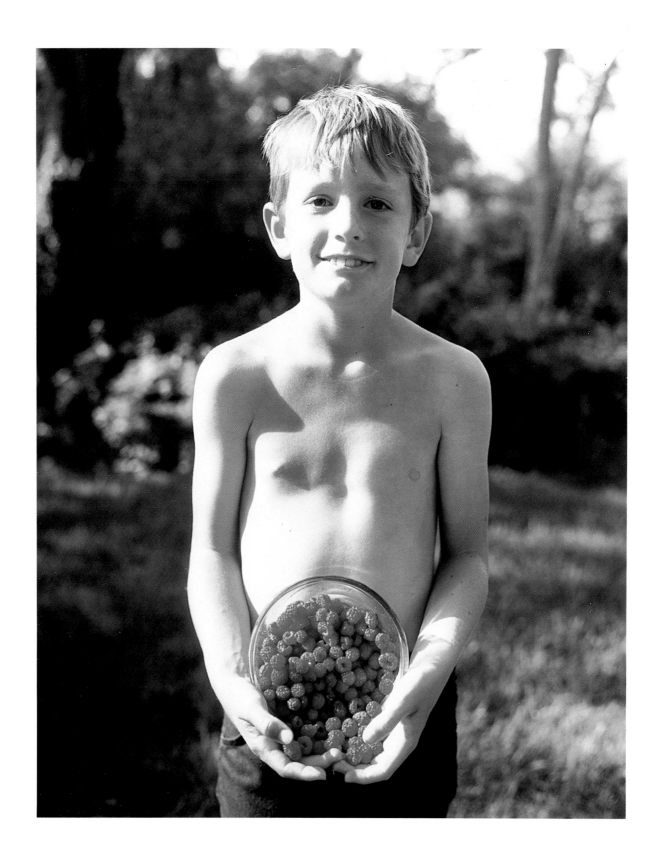

Joel Meyerowitz *Eric*

Hope is a risk that must be run.

GEORGES BERNANOS

Exhibition Checklist

Dimensions are given in inches (and centimeters); height precedes width. Unless otherwise noted, photographs have been lent by the artists.

JAMES H. BARKER
American, born 1936
1 *Sam Anthony and Simeon Tulik: Lappball, Nelson Island, Alaska*, 1976
 Gelatin silver print
 19⁵⁄₁₆ x 15³⁄₈ (49.1 x 39.2)
 Copyright © James Barker, 1976
 Illustrated on page 29

2 *Byron Hunter, Elia Charlie, Oscar River: Fourth of July at Black River, Scammon Bay, Alaska*, 1980
 Gelatin silver print
 18¹⁵⁄₁₆ x 12⁹⁄₁₆ (48.2 x 31.9)
 Copyright © James Barker, 1980
 Illustrated on page 28

BILL BRANDT
English, born Germany, 1904
3 *East End Girl Dancing the Lambeth Walk*, ca. 1930s
 Gelatin silver print
 Marlborough Gallery, New York City
 13½ x 11½ (34.4 x 29.3)
 Copyright © Bill Brandt, Photo Researchers, Inc.
 Illustrated on page 24

ELEANOR BRIGGS
American, born 1939
4 *Inmates*, 1976
 Gelatin silver print
 7⅛ x 11 (20.6 x 27.9)
 Anonymous Lender
 Illustrated on page 68

5 *Mary Dancing*, 1977
 Gelatin silver print
 13⁷⁄₁₆ x 8¹⁵⁄₁₆ (34.2 x 22.7)
 Illustrated on page 73

6 *The Milkweed Deva at Work* (Portrait of Ralph Steiner), 1980
 Gelatin silver print
 8⅝ x 13⅛ (22 x 33.4)
 Illustrated on page 70

ROBIN BROWN
American, born 1944
7 *Rockingham Meeting House*, 1976
 Gelatin silver print
 6⁷⁄₁₆ x 8⅛ (16.4 x 25.7)
 Illustrated on page 94

WYNN BULLOCK
American, 1902–1975
8 *The Forest*, 1956
 Gelatin silver print
 9½ x 7⁹⁄₁₆ (24.2 x 19.2)
 Center for Creative Photography, University of Arizona
 Illustrated on page 106

9 *Stark Tree*, 1956
 Gelatin silver print
 7⁹⁄₁₆ x 9⅛ (19.2 x 23.1)
 Center for Creative Photography, University of Arizona
 Illustrated on page 105

10 *The Shore*, 1966
 Gelatin silver print
 7¾ x 8⅜ (19.7 x 21.4)
 Center for Creative Photography, University of Arizona
 Illustrated on page 104

PAUL CAPONIGRO
American, born 1932
11 *Frosted Window*, from *Portfolio II*, 1957
 Gelatin silver print

7¾ x 9⅛ (19.8 x 23.2)
Hood Museum of Art, Dartmouth College
EL.PH.981.47.1
Illustrated on page 108

12 *Brewster, New York*, 1963
Gelatin silver print
8 x 6¼ (20.3 x 15.9)
Illustrated on page 93

13 *Winthrop, Massachusetts*, 1965
Gelatin silver print
9½ x 7⅜ (24 x 18.8)
Illustrated on page 81

14 *Yosemite, California*, 1975
Gelatin silver print
7½ x 8½ (19.1 x 21.7)
Illustrated on page 110

15 *Tecate, Mexico*, 1979
Gelatin silver print
9⁹⁄₁₆ x 13⅛ (24.3 x 33.5)
Illustrated on page 109

HENRI CARTIER-BRESSON
French, born 1908
16 *On the Banks of the Marne*, 1938
Gelatin silver print
9⁵⁄₁₆ x 14 (23.8 x 35.6)
Lent by Helen Wright
Illustrated on page 46

17 *Hyde Park, London*, 1958
Gelatin silver print
9⅜ x 13¹⁵⁄₁₆ (23.8 x 35.5)
Lent by Helen Wright
Illustrated on page 41

WILLIAM CLIFT
American, born 1944
18 *Balcony Benches, Old City Hall, Boston*, 1970
Gelatin silver print
7½ x 9½ (19.1 x 24.1)
Illustrated on page 97

19 *Eduard Faitout, Vessey, France*, 1977
Gelatin silver print
9⁹⁄₁₆ x 6⁹⁄₁₆ (24.4 x 16.7)
Illustrated on page 38

GABRIEL AMADEUS COONEY
American, born 1947
20 *Winifred Arms*, 1981
Gelatin silver print
13⁷⁄₁₆ x 10⁷⁄₁₆ (34.2 x 26.5)
Illustrated on page 39

ROBERT DAWSON
American, born 1950
21 *Untitled, #7* from the *Mono Lake Series*
Gelatin silver print
7¹³⁄₁₆ x 13⁵⁄₁₆ (19.9 x 33.8)
Copyright © Robert Dawson, 1980
Illustrated on page 111

ROBERT DOISNEAU
French, born 1912
22 *In the Courtyard of the Louvre*, n.d.
Gelatin silver print
8½ x 11⅝ (21.8 x 29.6)
Lent by Naomi and Walter Rosenblum
Illustrated on page 65

ELLIOTT ERWITT
American, born France, 1928
23 *Hungary*, 1964
Gelatin silver print
8⅛ x 12 (20.5 x 30.6)
Illustrated on page 69

WALKER EVANS
American, 1903–1975
24 *Burrow's Kitchen, Hale County, Alabama*, 1936
Gelatin silver print
9⅜ x 6⅝ (23.8 x 16.3)
The Museum of Modern Art,
New York
Stephen R. Currier Memorial Fund
Illustrated on page 92

RICHARD FARRELL
American, born 1947
25　*Storm Watchers*, 1980
Cibachrome print
19½ x 14¼ (49.7 x 36.2)
Illustrated on page 120

IRENE FERTIK
American, born 1943
26　*Step by Step* (Judith Jamison conducting a
workshop at the University of Vermont),
1984
Gelatin silver print
11½ x 7¹¹⁄₁₆ (29.3 x 19.5)
Lent by Burlington Free Press
Illustrated on page 61

DOUGLAS FRANTZ
American, born 1943
27　*Farm Buildings, near Traverse City, Michigan*,
1976
EP2 Color Process Print
9⁵⁄₁₆ x 6³⁄₁₆ (23.7 x 15.8)
Illustrated on page 119

28　*Rocks, Point Lobos, California*, 1977
EP2 Color Process Print
6⁵⁄₁₆ x 9⁵⁄₁₆ (16.1 x 23.7)
Illustrated on page 118

GEORGE W. GARDNER
American, born 1940
29　*Portrait of Neihardt*, 1962
Gelatin silver print
9¹¹⁄₁₆ x 13¹³⁄₁₆ (24.6 x 35.2)
Illustrated on page 40

WILLIAM A. GARNETT
American, born 1916
30　*Snow Geese with Reflection of the Sun over Buena
Vista Lake, California*, 1953
Gelatin silver print
19⅝ x 15¹¹⁄₁₆ (50 x 40)
Copyright © William A. Garnett, 1953
Illustrated on page 107

31　*Two Trees on Hill with Shadows, Paso Robles,
California*, 1974
Gelatin silver print
15¾ x 19¹¹⁄₁₆ (40.2 x 50)
Copyright © William A. Garnett, 1974
Illustrated on page 102

ERNST HAAS
American, born Austria, 1921
32　*Untitled* (Wet leaf), 1963
Type "C" print
11 x 14 (17.5 x 19.8)
Illustrated on page 137

33　*Untitled* (Deer in Africa), 1970
Type "C" print
11 x 14 (17.5 x 19.8)
Illustrated on page 136

34　*Untitled* (Skeleton leaves, Ecuador), 1970
Type "C" print
11 x 14 (17.5 x 19.8)
Illustrated on page 135

35　*Untitled* (Boy with dog), 1975
Type "C" print
11 x 14 (17.5 x 19.8)
Illustrated on page 134

KEN HEYMAN
American, born 1930
36　*Untitled* (Girls with bows), 1956
Gelatin silver print
8 x 11¹⁵⁄₁₆ (22.9 x 30.3)
Illustrated on page 27

37　*Untitled* (Indonesian dancer), 1959
Gelatin silver print
8¹⁵⁄₁₆ x 10⅜ (22.7 x 26.4)
Illustrated on page 45

38　*Untitled* (Mommy's tummy), 1962
Gelatin silver print
12 x 8 (30.5 x 20.4)
Illustrated on page 21

39　*Untitled* (Girl swinging), 1964

Gelatin silver print
11¹⁵/₁₆ x 8¹⁵/₁₆ (30.4 x 22.8)
Illustrated on page 32

40 *Untitled* (Child leaping), 1968
Gelatin silver print
11¹/₁₆ x 9 (28.2 x 23)
Illustrated on page 33

41 *Untitled* (Girl in earnest), 1969
Gelatin silver print
11¾ x 9 (29.9 x 23)
Illustrated on page 34

LEWIS HINE
American, 1874–1940

42 *Playground in a Tenement Alley, Boston*, 1909
Gelatin silver print
4¹³/₁₆ x 6¹³/₁₆ (12.2 x 17.3)
International Museum of Photography
at George Eastman House
Illustrated on page 26

EVELYN HOFER
English, born Germany, Contemporary

43 *Proprietor of the Caracoles Restaurant, Barcelona*,
1962
Gelatin silver print
14⅛ x 11 (36 x 28.1)
Illustrated on page 47

DEWITT JONES
American, born 1943

44 *Woodpecker*, 1972
Type "C" print from 35 mm Kodachrome original
9½ x 14 (24.2 x 35.7)
Illustrated on page 126

45 *Tree with Rake*, 1975
Type "C" print from 35 mm Kodachrome original
9½ x 14 (24.2 x 35.7)
Illustrated on page 122

46 *Farmer with St. Bernard*, 1975
Type "C" print from 35 mm Kodachrome original
9½ x 14 (24.2 x 35.7)
Illustrated on page 123

47 *Redwoods and Rhododendrons*, 1976
Type "C" print from 35 mm Kodachrome original
9½ x 14 (24.2 x 35.7)
Illustrated on page 124

48 *Single Tree*, 1979
Cibachrome print from 35 mm Kodachrome
original
9½ x 14 (24.2 x 35.7)
Not illustrated

49 *Landscape*, 1980
Type "C" print from 35 mm Kodachrome original
9½ x 14 (24.2 x 35.7)
Illustrated on page 125

TAMARA KAIDA
Russian, born Austria, 1946

50 *Woodsprite*, 1981
Gelatin silver print
14 x 13½ (35.7 x 34.4)
Illustrated on page 22

MICHAEL KENNA
English, born 1953

51 *Swings, Catskill Mountains, N.Y., U.S.A.*,
1977
Gelatin silver print
5¹⁵/₁₆ x 8¹⁵/₁₆ (15.1 x 22.8)
Lent by Stephen Wirtz Gallery, San Francisco, Ca.
Illustrated on page 89

ANDRÉ KERTÉSZ
American, born Austria-Hungary, 1894–1985

52 *The Concierge's Dog*, 1926
Gelatin silver print
9⅝ x 7¼ (24.5 x 18.4)
Lent by the Estate of André Kertész
Illustrated on page 74

B. A. KING
Canadian, born 1934

53 *February Morning*, 1977
Gelatin silver print
8⅝ x 12⅞ (22 x 32.8)
Illustrated on page 64

54 *The History Prize*, 1977
Gelatin silver print
8⁹⁄₁₆ x 12¾ (21.8 x 32.4)
Illustrated on page 56

55 *Ralph and Caroline*, 1980
Gelatin silver print
8½ x 12¾ (21.7 x 32.5)
Anonymous Lender
Illustrated on page 57

56 *Grace*, 1982
Gelatin silver print
9¹⁄₁₆ x 12⅞ (23 x 32.8)
Illustrated on page 96

SUSAN LANDGRAF
American, born 1948
57 *Jessica*, 1975
Gelatin silver print
6³⁄₁₆ x 9½ (15.7 x 24.2)
Copyright © Susan Landgraf, 1983
Illustrated on page 30

DOROTHEA LANGE
American, 1895–1965
58 *Irish Child (County Clare, Ireland)*, 1954
Gelatin silver print
10 x 10 (25.5 x 25.5)
Dorothea Lange Collection, Gift of Paul Schuster
Taylor, The Oakland Museum, Oakland,
California
Copyright © The City of Oakland, The Oakland
Museum, California
Illustrated on page 23

ALMA LAVENSON
American, born 1897
59 *San Ildefonso Indians, New Mexico*, 1941
Gelatin silver print
8⅞ x 7½ (22.6 x 19.2)
Illustrated on page 43

ARTHUR LAZAR
American, born 1940
60 *Pecos Cloud, New Mexico*, 1970

Gelatin silver print
11¹⁄₁₆ x 15¹⁵⁄₁₆ (28.2 x 40.6)
Illustrated on page 103

STEPHEN LEWIS
American, born 1952
61 *Bob, Manchester*, 1985
Gelatin silver print
21⅝ x 22³⁄₁₆ (55 x 56.4)
Illustrated on page 72

JEROME LIEBLING
American, born 1924
62 *Handball Player, Miami Beach, Florida*, 1978
Gelatin silver print
8¹¹⁄₁₆ x 11¹¹⁄₁₆ (22.1 x 29.8)
Illustrated on page 48

LAWRENCE McFARLAND
American, born 1942
63 *Wheatfield*, 1976
Gelatin silver print
10½ x 16¹⁵⁄₁₆ (26.7 x 43.1)
Anonymous Lender
Illustrated on page 101

JOEL MEYEROWITZ
American, born 1938
64 *Reading*, 1976
RC Ektacolor print
23½ x 18½ (59.4 x 47.1)
Illustrated on page 140

65 *The Yellow Room*, 1977
RC Ektacolor print
18½ x 23½ (47.1 x 59.4)
Illustrated on page 138

66 *The Table*, 1981
RC Ektacolor print
23½ x 18½ (59.4 x 47.1)
Illustrated on page 141

67 *Fruit*, 1983
RC Ektacolor print
23½ x 18½ (59.4 x 47.1)
Illustrated on page 139

68 *Eric*, 1983
RC Ektacolor print
23½ x 18½ (59.4 x 47.1)
Illustrated on page 142

OLIVIA PARKER
American, born 1941
69 *Vicksburg Feather*, 1976
Gelatin silver print
4¹¹⁄₁₆ x 6⅝ (12 x 16.9)
Copyright © Olivia Parker, 1976
Illustrated on page 91

70 *Dance*, 1977
Gelatin silver print
4¹¹⁄₁₆ x 6⅝ (12 x 16.9)
Copyright © Olivia Parker, 1977
Illustrated on page 76

ELIOT PORTER
American, born 1901
71 *Glen Canyon Series*, c. 1965
Dye transfer print
10½ x 8⅛ (26.8 x 20.6)
Lent by Scheinbaum and Russek, Santa Fe,
New Mexico
Copyright © Eliot Porter
Illustrated on page 129

72 *Water Stain, Music Temple, Glen Canyon, Utah,*
c. 1965
Dye transfer print
10⁵⁄₁₆ x 8¹⁄₁₆ (26.3 x 20.5)
Lent by Scheinbaum and Russek, Santa Fe,
New Mexico
Copyright © Eliot Porter
Illustrated on page 128

73 *Balanced Rock Canyon, Glen Canyon, Utah,*
c. 1965
Dye transfer print
10⁵⁄₁₆ x 8⅛ (26.3 x 20.6)
Lent by Scheinbaum and Russek, Santa Fe,
New Mexico
Copyright © Eliot Porter
Illustrated on page 127

74 *American Eider's Nest, Barred Islands, Maine,*
c. 1965
Dye transfer print
10¼ x 8³⁄₁₆ (26 x 20.9)
Lent by Scheinbaum and Russek, Santa Fe,
New Mexico
Copyright © Eliot Porter
Illustrated on page 130

75 *Apples on Tree after Frost, Tesuque, New Mexico,*
1966
Dye transfer print
10⁹⁄₁₆ x 8⅛ (26.8 x 20.6)
Lent by Scheinbaum and Russek, Santa Fe, New
Mexico
Copyright © Eliot Porter
Illustrated on page 131

76 *Redbud Tree in Red River Gorge, Kentucky*, 1968
Dye transfer print
10 x 8¹⁄₁₆ (25.4 x 20.5)
Lent by Scheinbaum and Russek, Santa Fe, New
Mexico
Copyright © Eliot Porter
Illustrated on page 132

CHARLES PRATT
American, 1926–1976
77 *Roxbury, Connecticut* (Table under the trees),
1964
Gelatin silver print
8⁷⁄₁₆ x 12¹⁵⁄₁₆ (21.5 x 32.9)
Lent by Julie F. Pratt
Illustrated on page 87

78 *Roxbury, Connecticut* (Cow lying down in
field), 1975
Gelatin silver print
10⁹⁄₁₆ x 13⁹⁄₁₆ (26.8 x 34.5)
Lent by Julie F. Pratt
Illustrated on page 86

BARBARA ROGASKY
American, born 1933
79 *Fire Wake*, 1981

Cibachrome print
10¹⁄₁₆ x 6¾ (25.7 x 17.2)
Illustrated on page 117

MILTON ROGOVIN
American, born 1909

80 *Untitled* (Wedding dance, lower West Side,
N.Y.C.), ca. 1969–72
Gelatin silver print
6⅞ x 6⁹⁄₁₆ (17.5 x 16.7)
Illustrated on page 58

81 *Untitled* (Couple dancing, Scotland), 1982
Gelatin silver print
6¹¹⁄₁₆ x 6¾ (17 x 17.1)
Illustrated on page 60

WALTER ROSENBLUM
American, born 1919

82 *Two Sisters on 105th Street*, ca. 1950
Gelatin silver print
7³⁄₁₆ x 8¾ (18.4 x 22.3)
Illustrated on page 31

JONATHAN SA'ADAH
American, born 1950

83 *Cris at Petrell House*, 1973
Goldtone printing-out paper print
5¹³⁄₁₆ x 8⁹⁄₁₆ (14.8 x 21.8)
The Hood Museum of Art, Dartmouth College,
Julia L. Whittier Fund. Ph.973.261
Illustrated on page 44

JOHN SHELDON
American, born 1952

84 *Interior, Plainfield, N.H.*, 1976
Gelatin silver print
8¹¹⁄₁₆ x 13 (22.1 x 33.2)
Copyright © John Sheldon, 1982
Illustrated on page 95

W. EUGENE SMITH
American, 1918–1978

85 *Maude Callen*, 1948
Gelatin silver print
15⅝ x 11³⁄₁₆ (39.8 x 28.4)

Philadelphia Museum of Art, SmithKline Beckman
Corporation Fund
Illustrated on page 55

86 *Country Doctor, Child, and Stitched Eye*, 1948
Gelatin silver print
12¾ x 9¹¹⁄₁₆ (32.4 x 24.6)
Philadelphia Museum of Art, SmithKline Beckman
Corporation Fund
Not illustrated

ROBERT SMITH
American, born 1947

87 *August Afternoon*, 1984
Gelatin silver print
9¹⁵⁄₁₆ x 11¹⁵⁄₁₆ (25.4 x 30.3)
Illustrated on page 84

LOU STOUMEN
American, born 1917

88 *The Kiss, Times Square*, 1982
Gelatin silver print
8 x 11¹⁵⁄₁₆ (20.4 x 30.4)
Copyright © Lou Stoumen, 1985
Illustrated on page 67

89 *Father and Son, N.Y.C.*, 1984
Gelatin silver print
9¹⁵⁄₁₆ x 8 (25.3 x 20.4)
Copyright © Lou Stoumen
Illustrated on page 54

PAUL STRAND
American, 1890–1976

90 *Susan Thompson, Cape Split, Maine*, 1945
Gelatin silver print
11⁵⁄₁₆ x 8⅞ (28.7 x 22.6)
Philadelphia Museum of Art, The Paul Strand
Retrospective Collection: 1915–1975. Gift of the
Estate of Paul Strand
Not illustrated

GEORGE A. TICE
American, born 1938

91 *Buggy, Farmhouse and Windmill*, from *The
Amish Portfolio*, 1965

Gelatin silver print
3¹⁄₁₆ x 6⁷⁄₁₆ (7.7 x 16.4)
The Hood Museum of Art, Dartmouth College
EL.PH.981.41.4
Illustrated on page 88

UNKNOWN
American, 19th century
92 *Portrait of Walt Whitman (1819–1892)*, n.d.
Albumen print
5⅝ x 3¹⁵⁄₁₆ (14.3 x 10.1)
The Hood Museum of Art, Dartmouth College.
Gift of Oswald D. Reich. PH.966.90.1
Illustrated on page 77

WILLARD VAN DYKE
American, 1906–1986
93 *Carson House, Eureka*, 1937
Gelatin silver print
9⅜ x 7⅜ (23.8 x 18.8)
Anonymous Lender
Illustrated on page 75

DAVID VESTAL
American, born 1924
94 *Anne Vestal in Washington Square, New York,*
1954
Gelatin silver print
8¹⁄₁₆ x 5⅜ (20.5 x 13.7)
Illustrated on page 25

DANIEL WEINER
American, 1919–1959
95 *Justice Learned Hand*, 1952
Gelatin silver print
12⅞ x 9¹³⁄₁₆ (32.7 x 25)
Lent by Sandra Weiner
Illustrated on page 51

MURRAY WEISS
American, born 1926
96 *Pavillion Bridge*, 1980
Gelatin silver print
13¹⁵⁄₁₆ x 17⁵⁄₁₆ (35.5 x 44.1)
Illustrated on page 83

97 *Chestnut Tree*, 1982
Gelatin silver print
15 x 18⁵⁄₁₆ (38.2 x 46.7)
Illustrated on page 82

98 *Monhegan Harbor*, 1985
Gelatin silver print
14¾ x 18⅜ (37.5 x 46.7)
Illustrated on page 113

ULRIKE WELSCH
American, born Germany, 1940
99 *George Lowell*, 1982
Gelatin silver print
12¹³⁄₁₆ x 8⁹⁄₁₆ (32.6 x 21.8)
Illustrated on page 49

MINOR WHITE
American, 1908–1976
100 *Sun over Pacific, Devil's Slide*, 1948
Gelatin silver print
3½ x 4½ (8.9 x 11.5)
The Art Museum, Princeton University,
The Minor White Archive
Illustrated on page 85

101 *Grand Tetons, Wyoming*, 1959
Gelatin silver print
9 x 11 (22.9 x 28)
The Art Museum, Princeton University,
The Minor White Archive
Illustrated on page 112

MARION POST WOLCOTT
American, born 1910
102 *Jitterbugging on Saturday night in a juke joint near*
Marcella Plantation, Clarksdale, Mississippi,
1939
Gelatin silver print
10⅞ x 9¾ (27.7 x 24.9)
Illustrated on page 59

103 *Winter visitors picnicking on running board of their*
car near trailer park, Sarasota, Florida, 1941
Gelatin silver print
8¹¹⁄₁₆ x 11¹⁵⁄₁₆ (22.1 x 30.3)
Illustrated on page 71

In Spite of Everything, Yes
was designed by Stephen Harvard,
and composed, printed, and bound
by Meriden-Stinehour Press in
Lunenburg, Vermont and Meriden,
Connecticut. Bembo and Diotima
are the text and display typefaces.